FAST & LOOSE

Graham Mitchell thanks Lemmy Kilmister,
Eddie Clarke, and Phil Taylor.

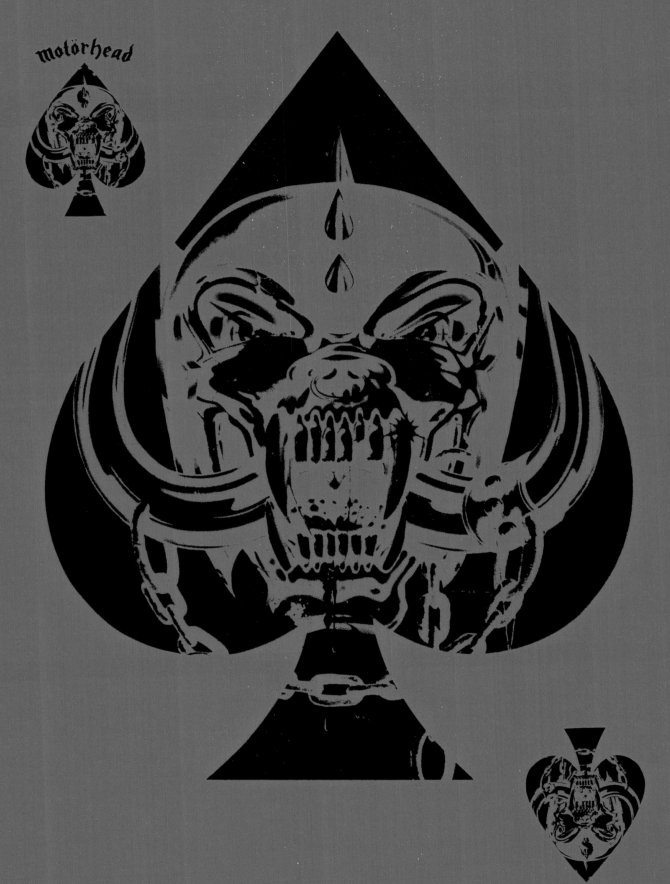

FAST & LOOSE

*Snapshots from the
Graham Mitchell Archive
1977-1982*

Introduction:
Take No Fucking Prisoners

rom 1976 to 1982 (plus another stint in 1985) I traveled countless miles of highway with Motörhead. I was their tour manager, their babysitter, their procurer of women, their procurer of drugs, procurer of everything. That was my job, so having another case out for cameras was a bit of a fucking encumbrance. But I loved photography, and somehow knew how important it all was. I knew I needed to capture at least some of those moments. Most of my images collected here are one-shot photos, and there's no flash on any of them. They were done at 400 ASA to speed up the film and take advantage of whatever natural light I could get, so I was always flying by the seat of my pants whenever I clicked the shutter. Yet I always felt I had to do it. Well, not "had" to but "was-driven-to-had-to."

So, how did I get involved with Motörhead in the first place? First things first: a little personal history! I come from a military family. My Dad was in the army, which made me an army brat, moving every three years before I was shipped off to boarding school at the grand age of eleven and a half. Dad expected a better future for me, so he was willing to pay shit pounds amount of money to send me to a public boarding school of "Victorian values." I spent five years learning to become an officer in the Royal Navy with the HMS Conway, which is on the Isle of Anglesey. I then went to university in London.

My girlfriend at university was named Geraldine. She knew a friend of Lemmy's named Motorcyle Irene, and we ended up squatting together right next to the London Whitechapel hospital. We had quite a big squat of fellow-minded students I suppose. The only way to survive in those times was to become a drug dealer, so dealing drugs paid for everything. In 1973, '74, and '75 we were having a great time!

I met Motörhead at their first Roundhouse gig in '75 after I went down with Gerry and 'Rene (as I called Geraldine and Irene). After that, we all hung out sometimes on Portobello Road—places like that—where we drank together, spent time together. Good times. So much partying! The whole lot of them—Lemmy, Eddie, and Phil—would come around. They were with Doug Smith, their manager at the time, and with United Artists as a label. Lemmy was in a bit of a fucking mess because thirty grand had been borrowed from UA to make that first Motörhead album. It basically got pissed up the wall—or snorted, shagged, fucked, and whatever.

Remember, heavy metal music had died a sort of death. Black Sabbath weren't really touring. Zeppelin were on the slide. And then you had all this West Coast hippie music that was everywhere, like The Doobie Brothers and The Eagles. A three-piece band like Motörhead putting out that sort of music was, well... different. I don't think a lot of people really realized how different it was. Promoters didn't want to fucking go there,

because they thought the venues were just gonna get fucked up by Lemmy and that the band would wreck everything. And it was too loud for most people.

I loved the music, so I went and started touring with them. I had a double-wheel-base-wide Ford transit, which was a fucking monster machine at the time. The back line fitted in quite nicely, so that, and obviously the small packages that I used to bring along gratis, were very helpful. Those early days were fun, but hard too. Most of us were living in squats; we didn't even have a real fucking wage! But I enjoyed it. It was fucking great.

What were Motörhead like back then? Lemmy was driven. He believed in what he was playing. He believed in Motörhead wholeheartedly when a lot of other people doubted. He was a true fucking rock-and-roller who lived for playing music. Women, drugs, slot machines, and whiskey too. Just the fun of life; that was Lemmy.

Eddie was a great mate. He loved Motörhead, loved the music, and was always a bit more into the band on a technical level I suppose. He wanted everything perfect. He was a great fucking blues guitarist. Listen to "Capricorn," "Metropolis," and "The Chase Is Better Than The Catch," which is probably one of my favorite songs.

Then you had Phil, and Phil really was just a filthy fucking animal, you know? A total Dennis the Menace of fucking mischief. He had that impish fucking attitude.

We started doing pubs like the Putney Tavern, the Red Lion, all these little dive spots in London—The Rolling Stones' old circuit. I think we got about 25-35 quid for a gig, which was fucking nothing really. I mean there's five of us on there with equipment; then you had to pay for the petrol, the chippie down the road for something to eat beforehand. You were lucky if you got given a crate of beer by the pub afterwards! So, if nothing else, we used to try and make sure our contract riders always included bourbon, vodka, and special brew. We liked truck stops, the greasy spoon. That was the thing we used to go for, cheap and cheerful…and it's amazing the amount of birds we used to meet up with at the Watford services on the M1 coming back from a gig at 1:00-2:30 in the morning.

The road was always an adventure. Lemmy's and Phil's humor was very Pythonesque. They also liked Peter Cook and Dudley Moore, so everybody else got wrapped up in it. We survived on their humour. You had no option because Lemmy'd put on a tape as we'd drive off to a gig and that was that! Eddie and Phil would be rolling joints in the back and they'd all be passed around, so by the time we got to most places we were pretty fucking ripped. It was just par for the course. Lemmy would be having a special brew at, you know, 10:00 am. By then he'd have already had about four snorts of whiz already. That was breakfast: whiz and special brew…

Despite all this going on—and my breathless role in the middle of it all (if

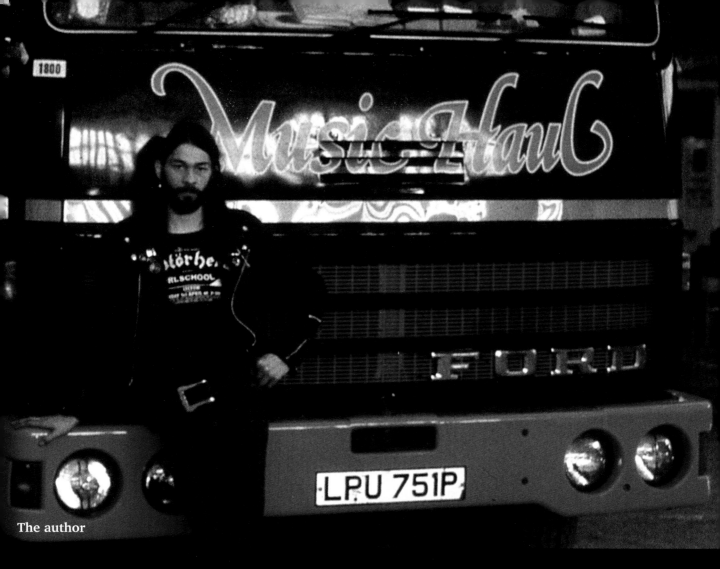

The author

you'll pardon me the drama), I was drawn to photography. I've always been taken by graphics, so I did a graphic design course between leaving university and doing Motörhead. It was through that that I got into taking pictures. Photography felt like a natural thing to me—the light and frame got to my senses. So I made the decision to go there, and it took selling quite a few fucking ounces of cocaine to pay for a Nikon 1000.

It was lucky that I took photos and actually got them developed in a proper professional photo lab. The film was expensive to process, and it also took time to go down to the shop and sort it all out. I knew how to develop my own film, but you need a special room for that, and in a fucking squat, that's a bit difficult—especially when you think the landlord or the Old Bill's gonna go crashing in through the door at any minute.

One thing I think when I look back over these photos is that I wish I'd a done a lot more personal shots. I did a fair few, but I didn't really think about it at the time—I was just trying to catch everything to do with the gigs, the music, and all that stuff. I'd see the band to the stage and then immediately go out into the house, jostle with the punters, and get what I could. The band always wanted me to tell them how the show was; they all wanted feedback on the gig, the fans, all of it, so I'd be out there watching and taking photos too. It's just a pity we didn't have any sort of technology, camera-wise, that we have nowadays. Thankfully, despite all the craziness, there are some good shots out of it all…

You know, there used to be a Motörhead saying: take no fucking prisoners. It always made sense to me, and I like to think these photos capture that in all its (occasionally grotty but never boring) glory.

"Sunrise, wrong side of another day
Sky high and six thousand miles away
Don't know how long I've been awake
Wound up in an amazing state"

- *from "Motörhead" by Lemmy Kilmister*

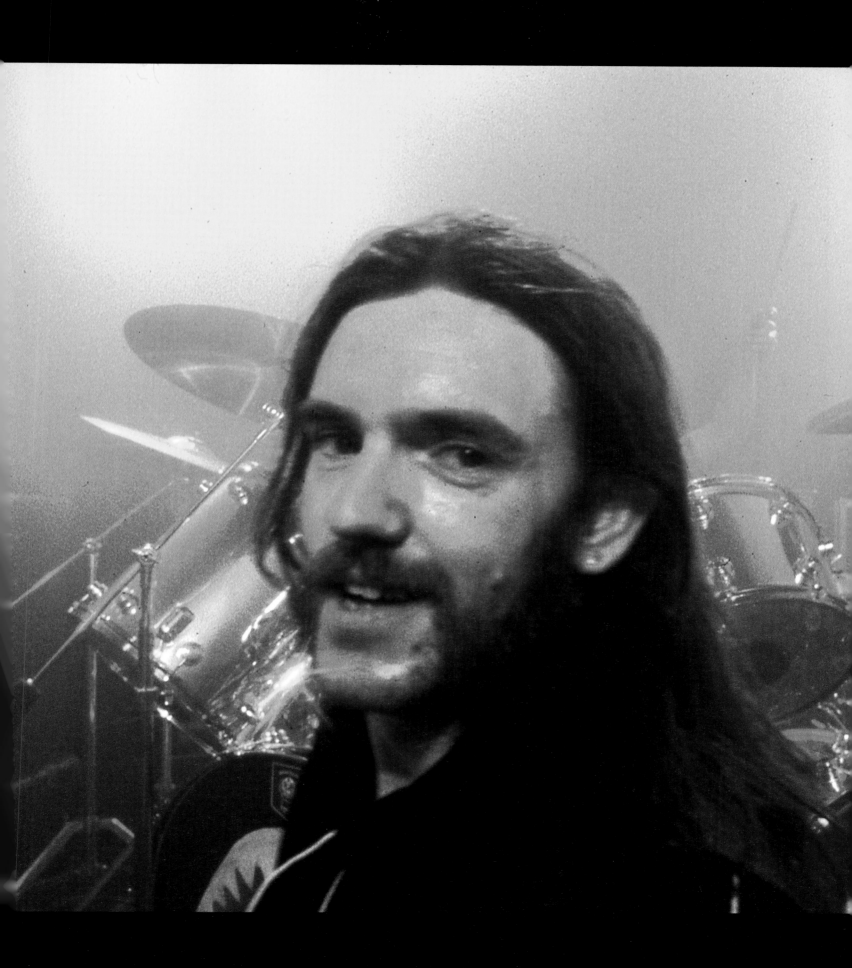

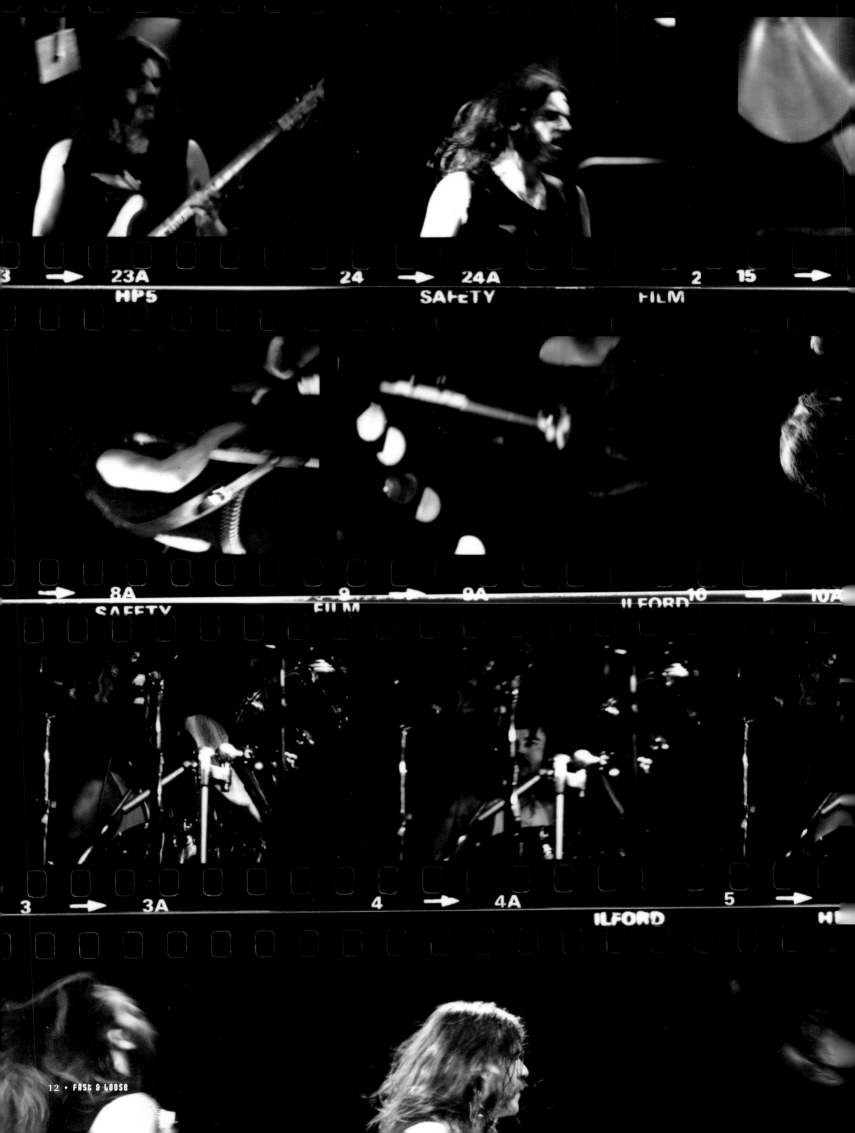

23A → 24 → 24A 2 15 →
HP5 SAFETY FILM

8A → 9 → 9A ILFORD 10 → 10A
SAFETY FILM ILFORD

3 → 3A 4 → 4A 5 →
ILFORD H

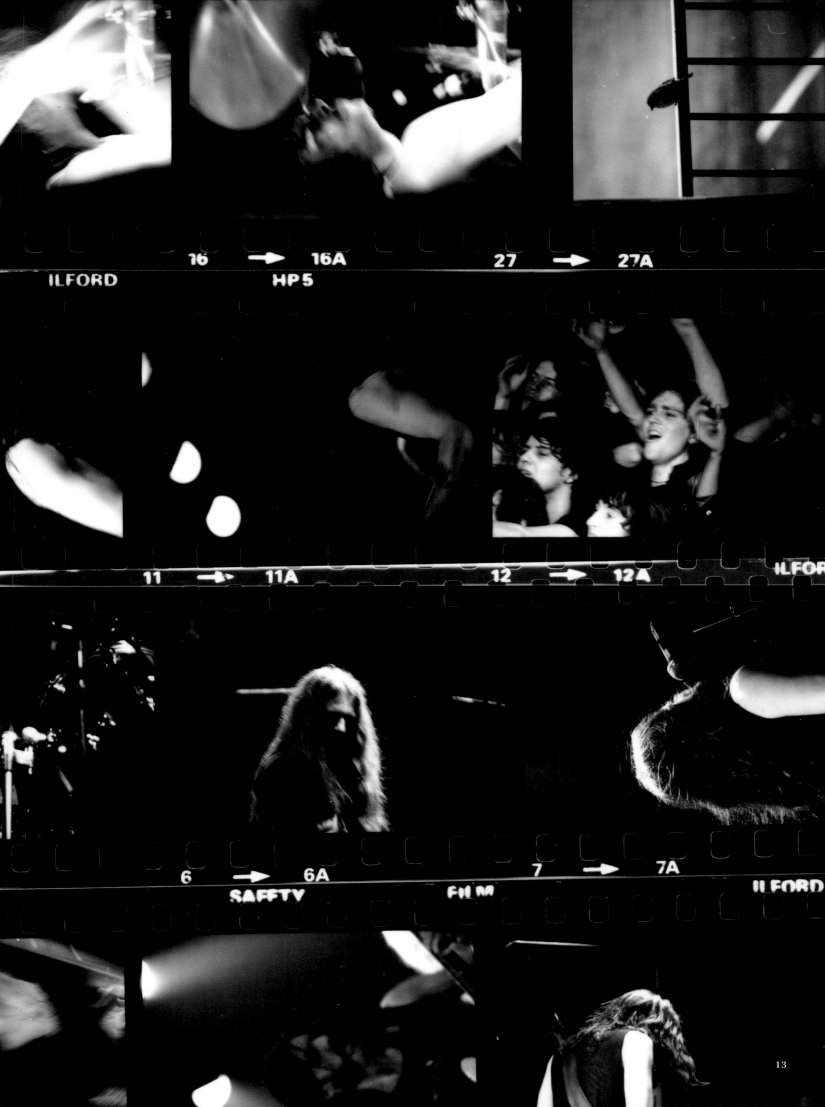

ILFORD HP5 16 → 16A 27 → 27A

11 → 11A 12 → 12A ILFOR

6 → 6A 7 → 7A ILFORD
SAFETY FILM

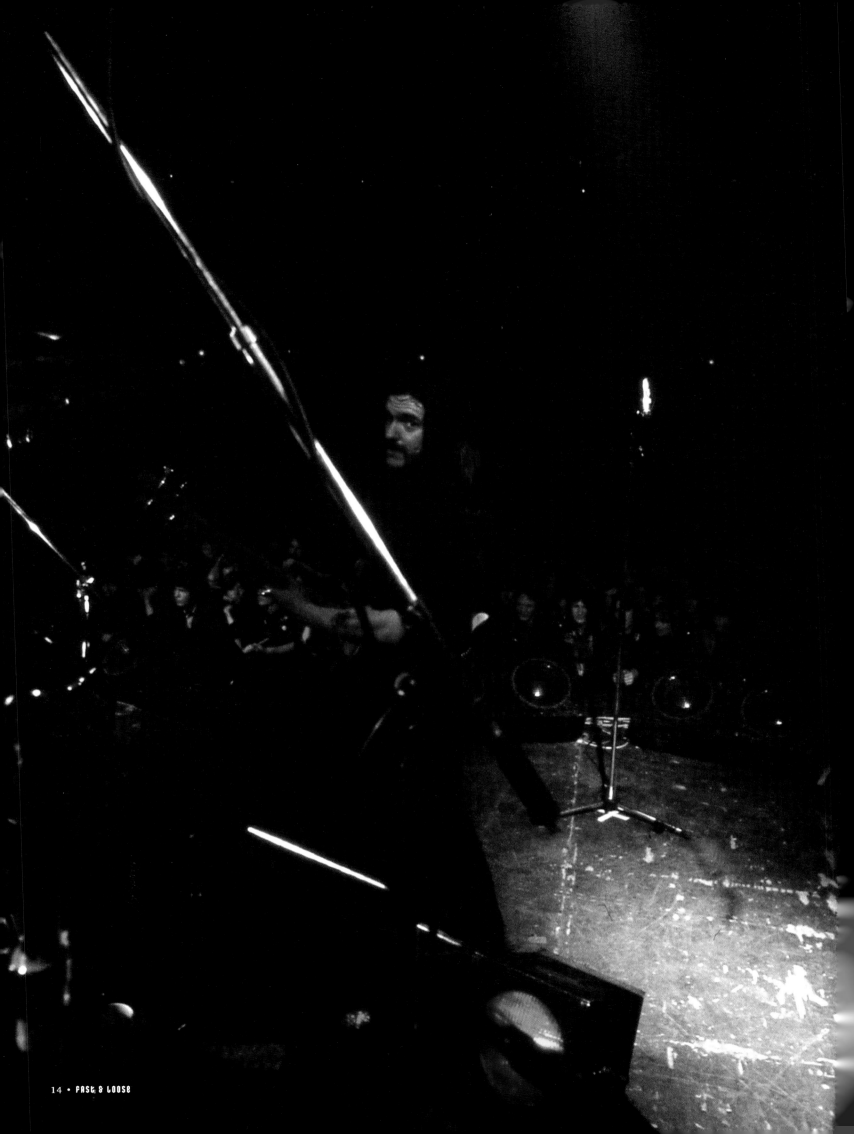

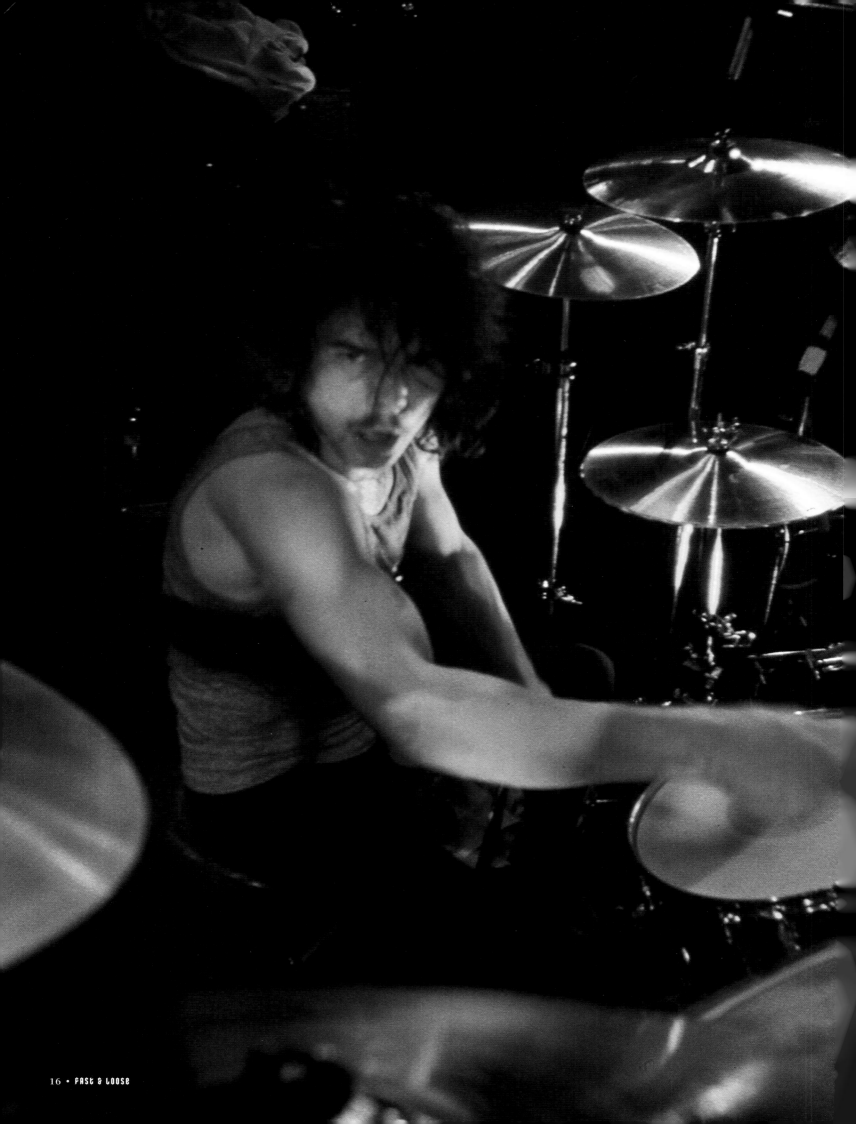

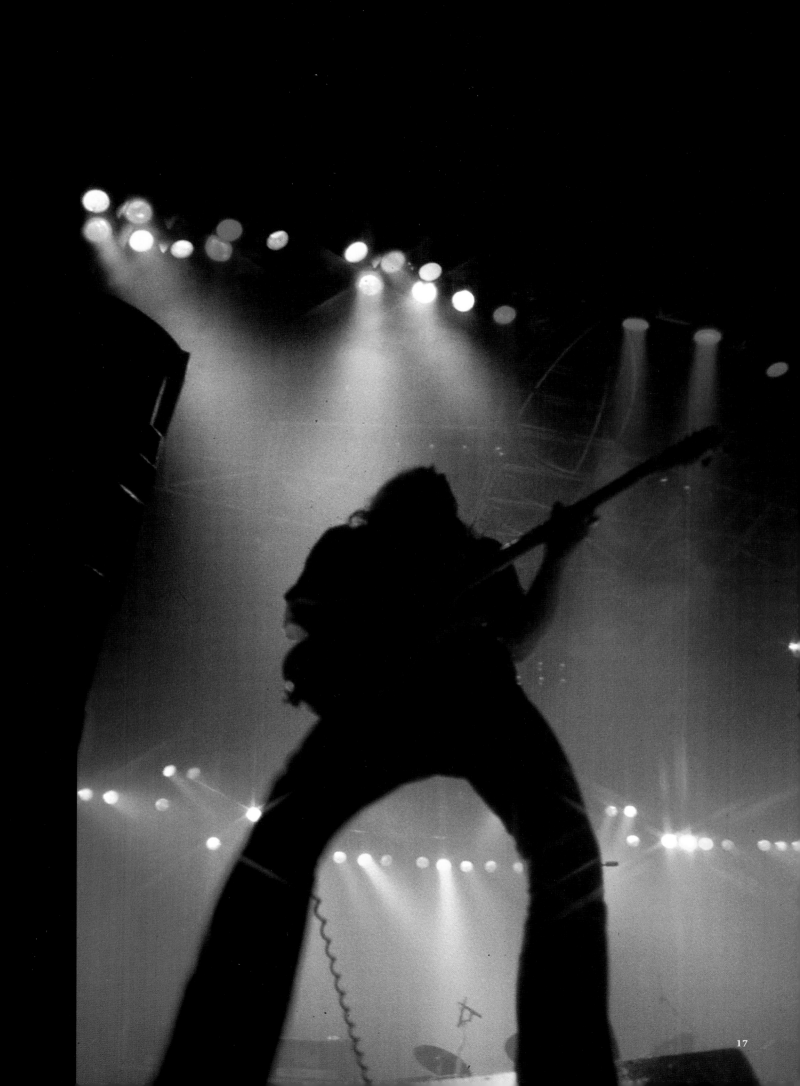

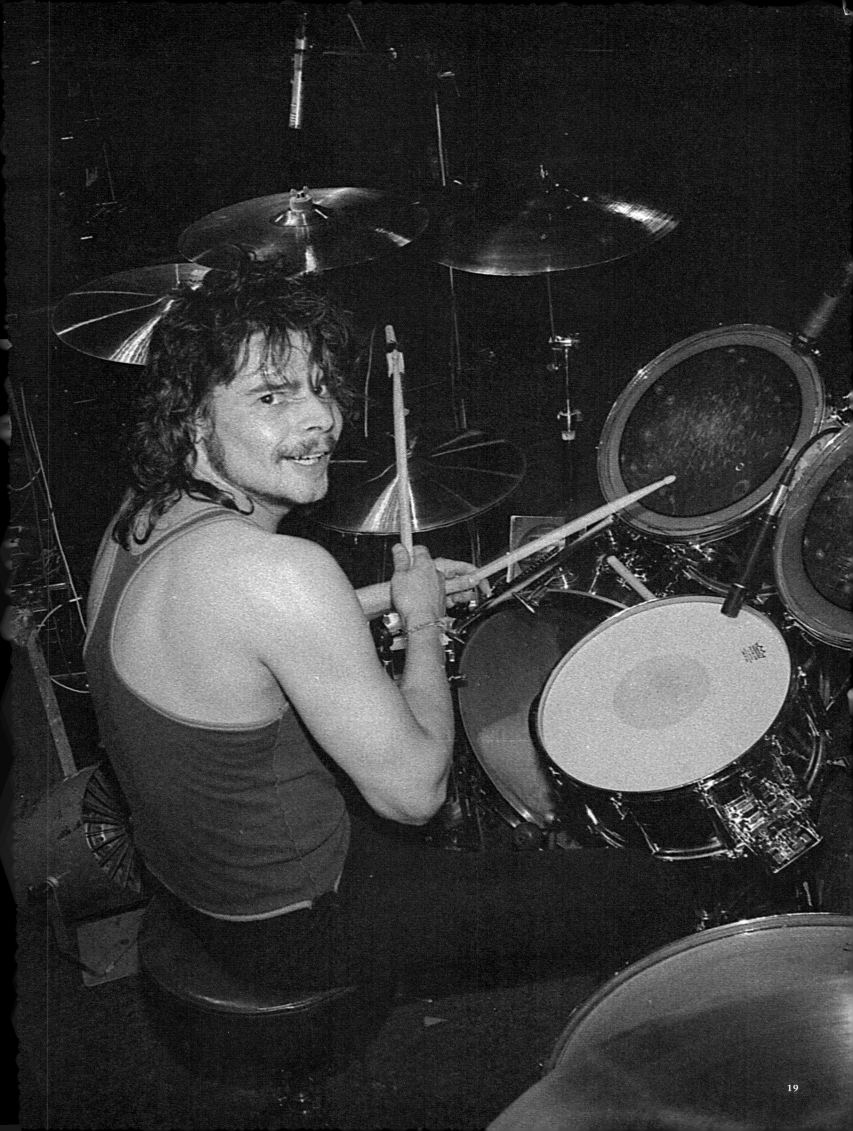

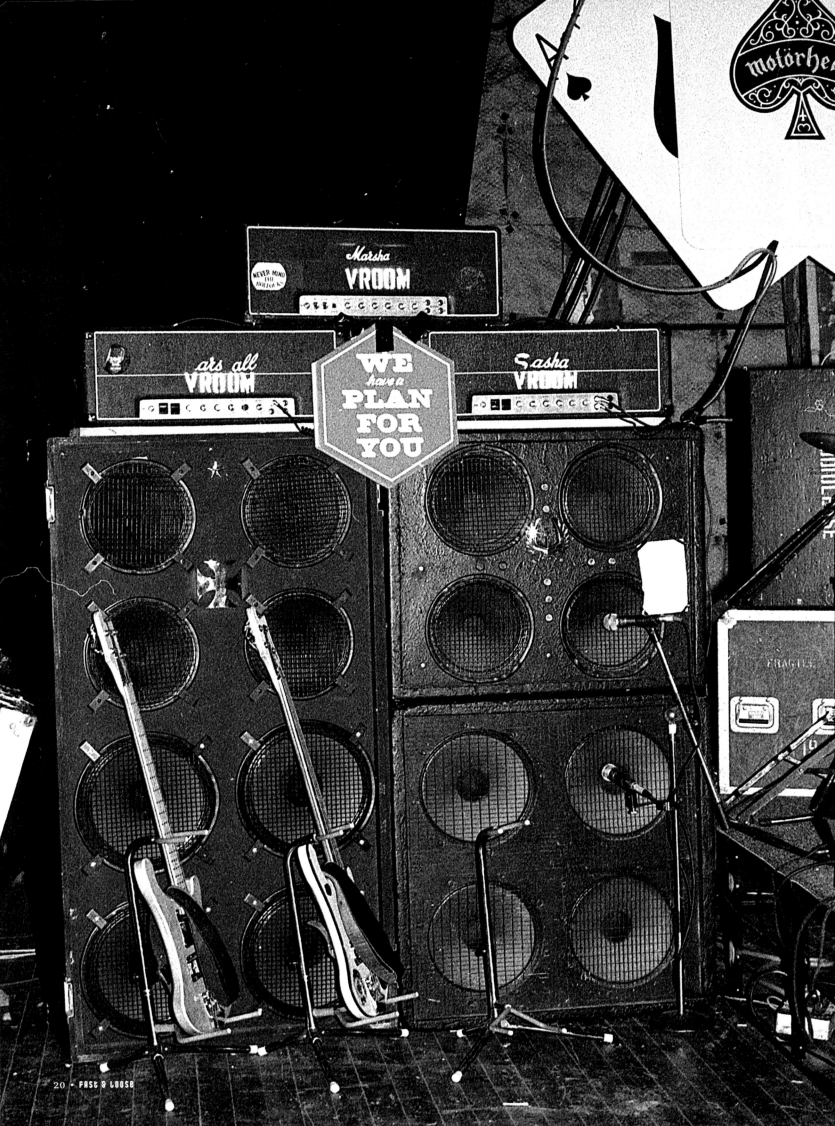

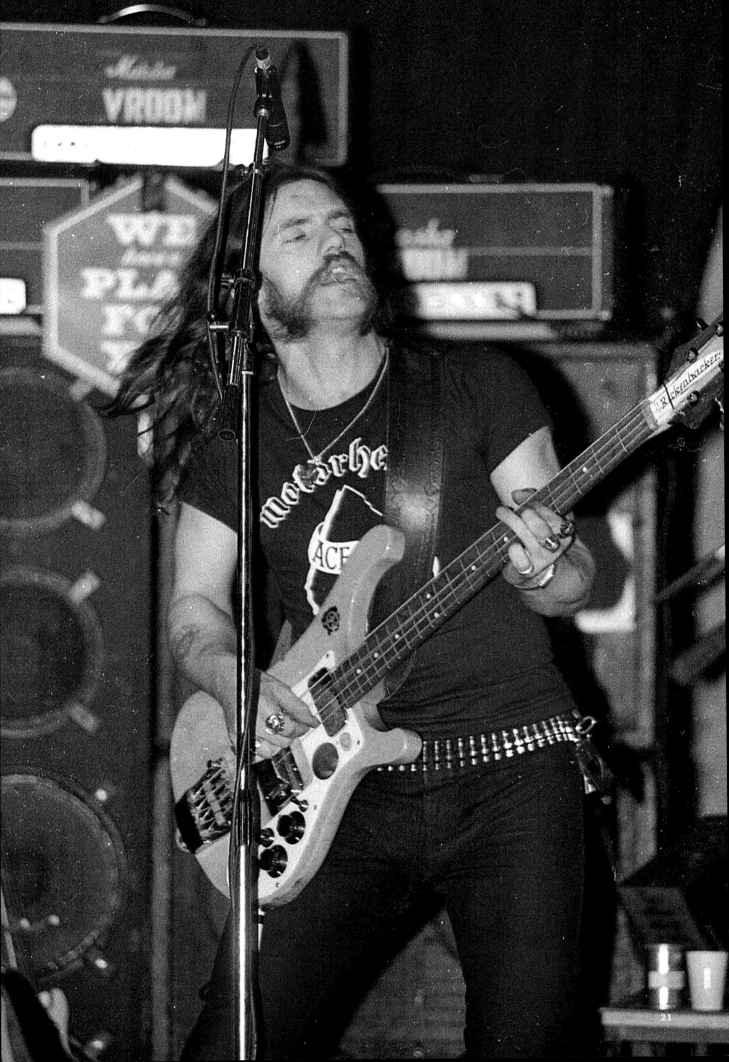

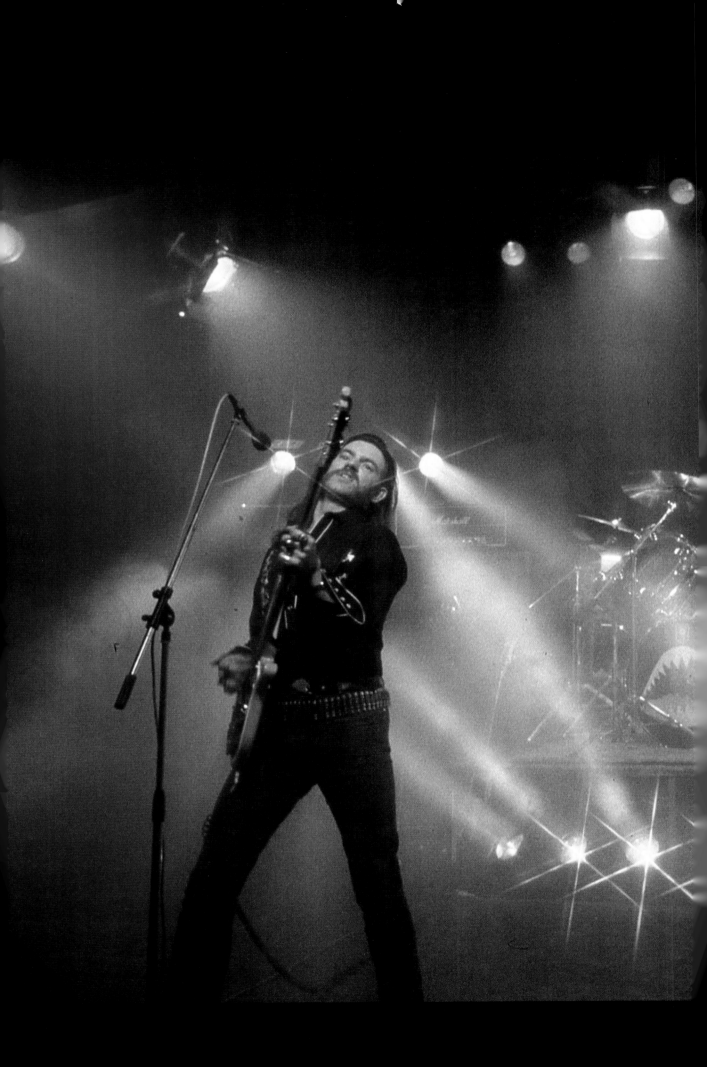

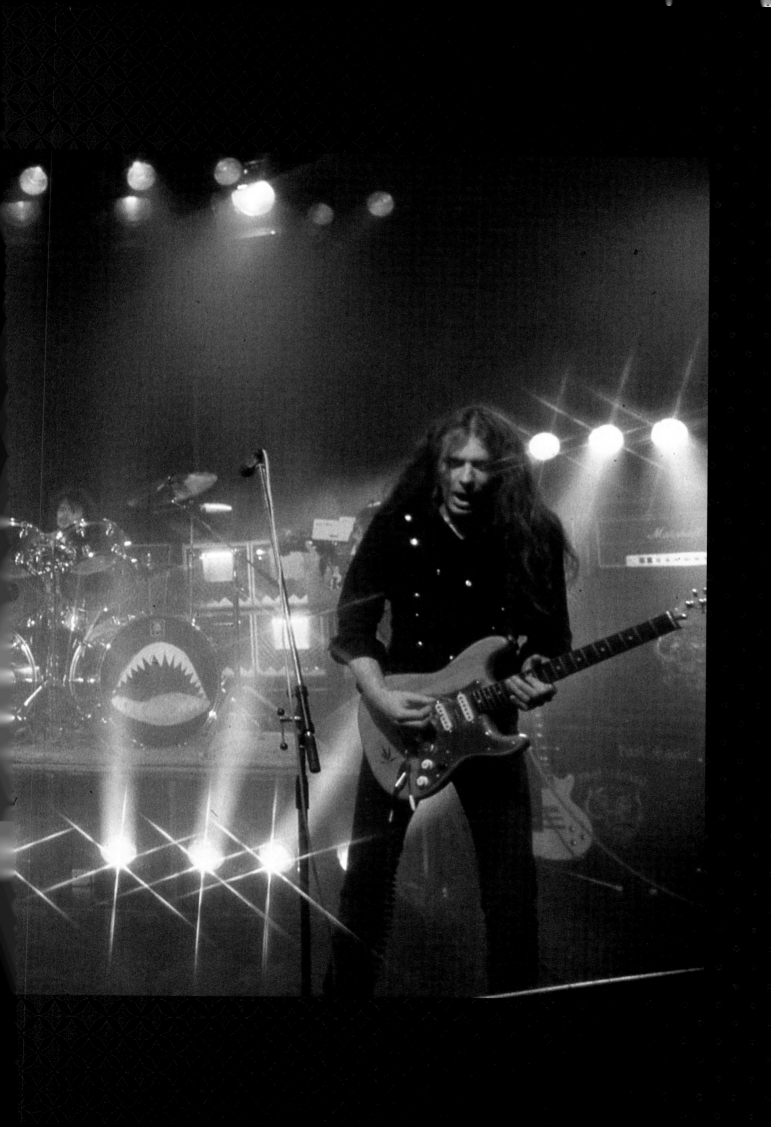

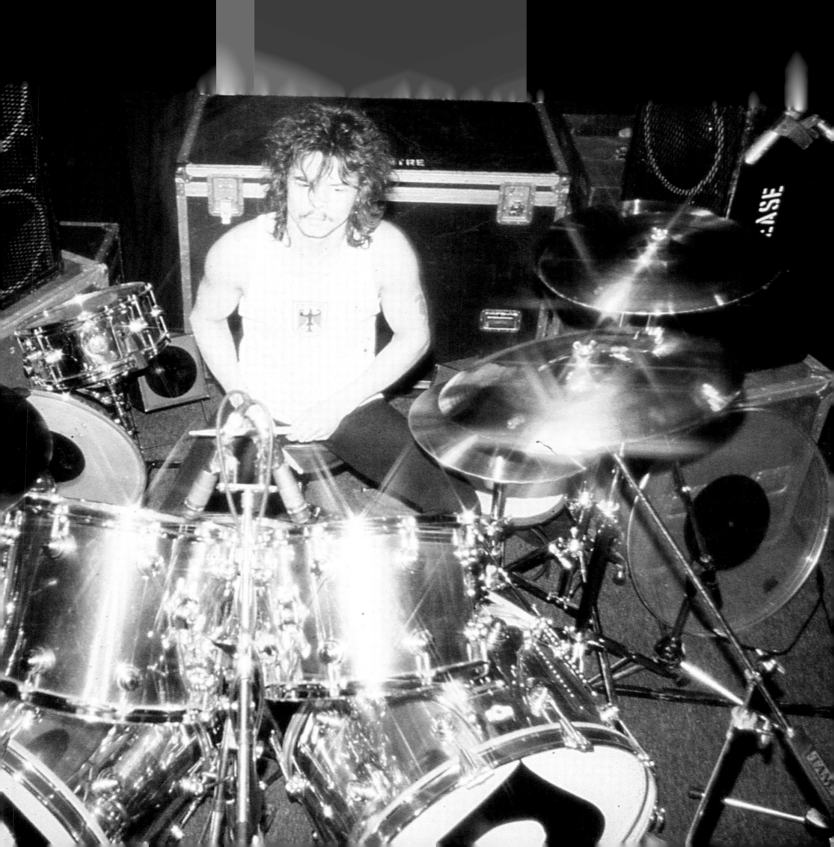

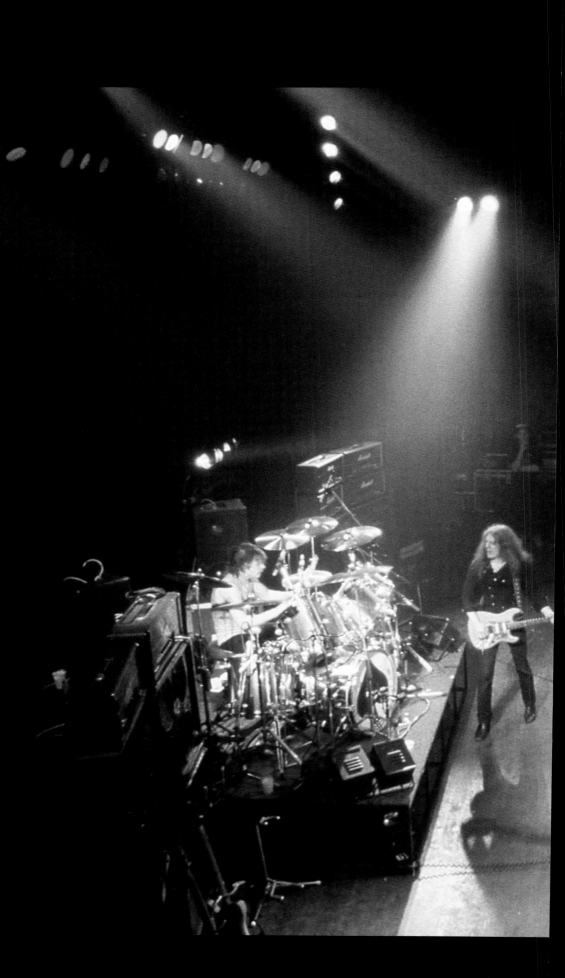

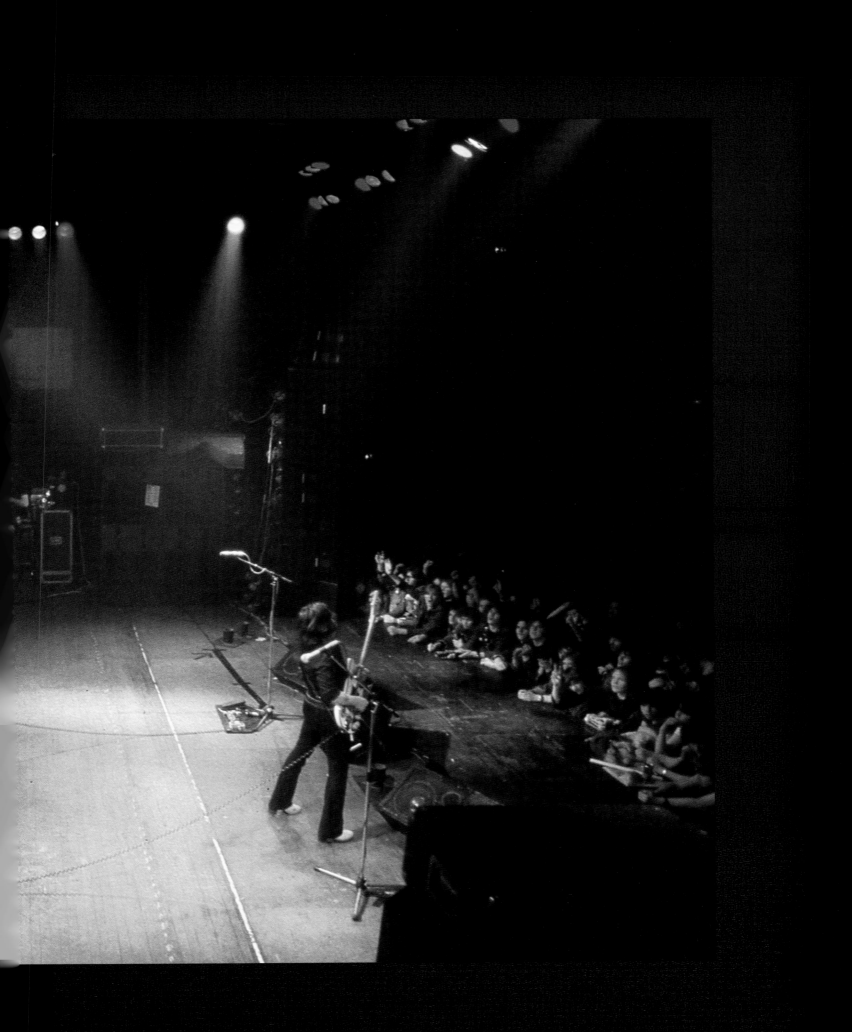

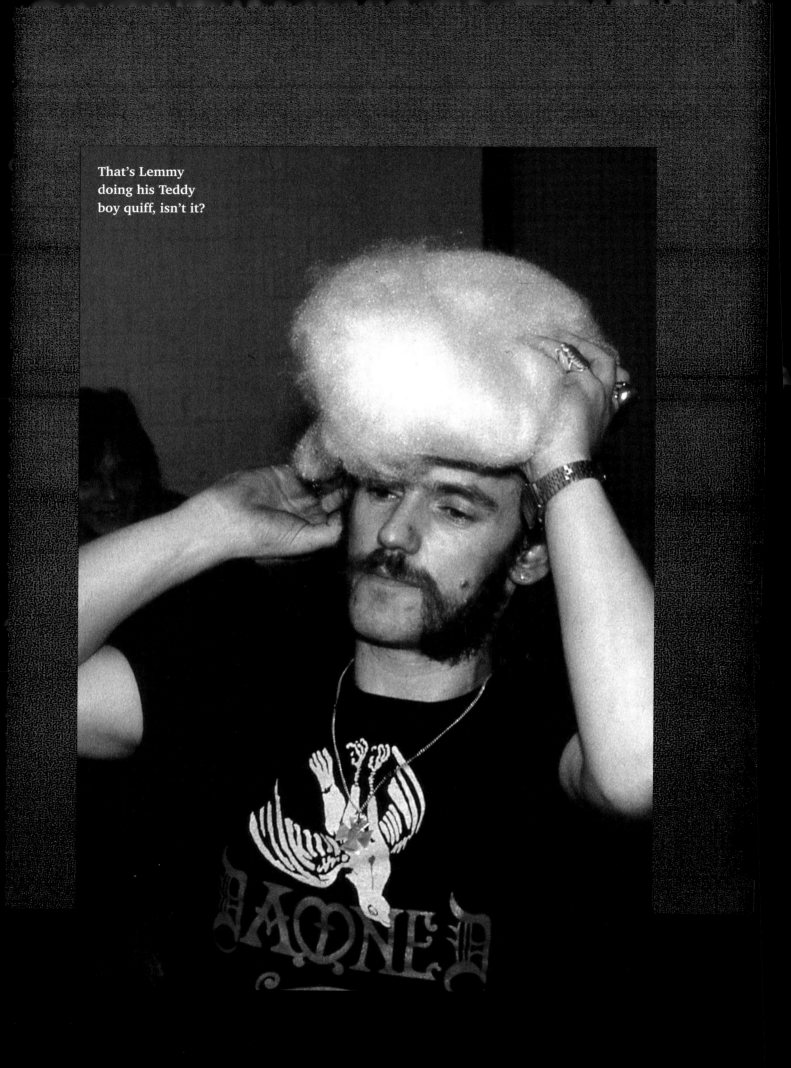

That's Lemmy
doing his Teddy
boy quiff, isn't it?

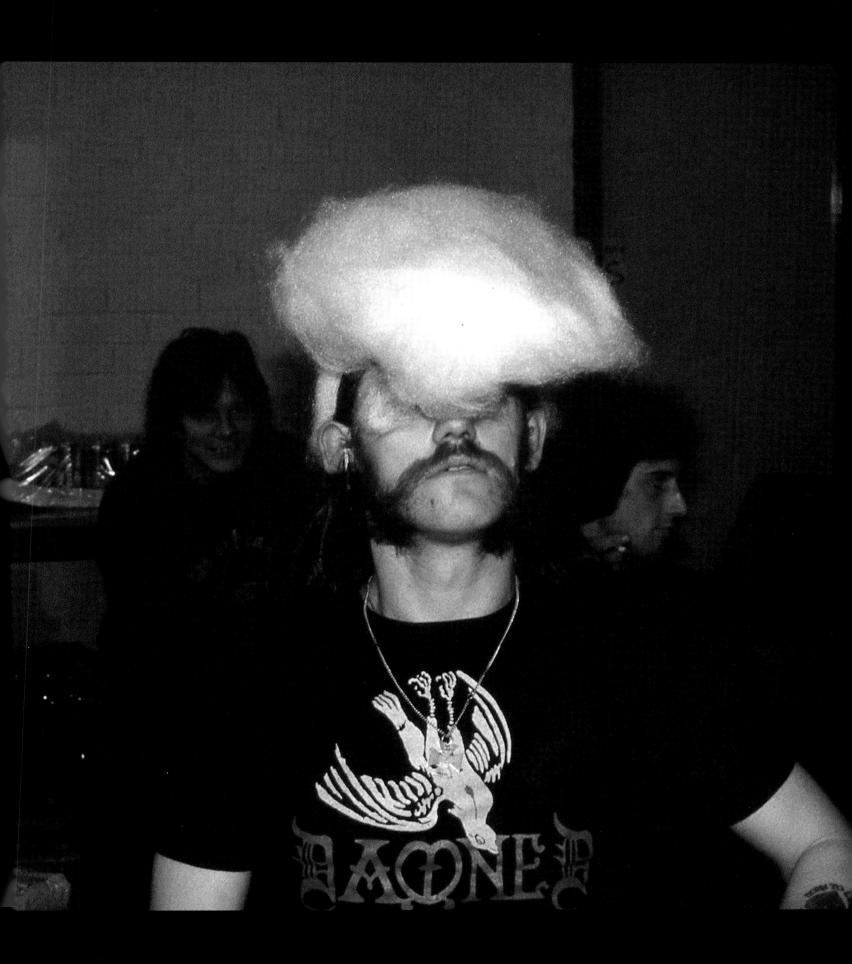

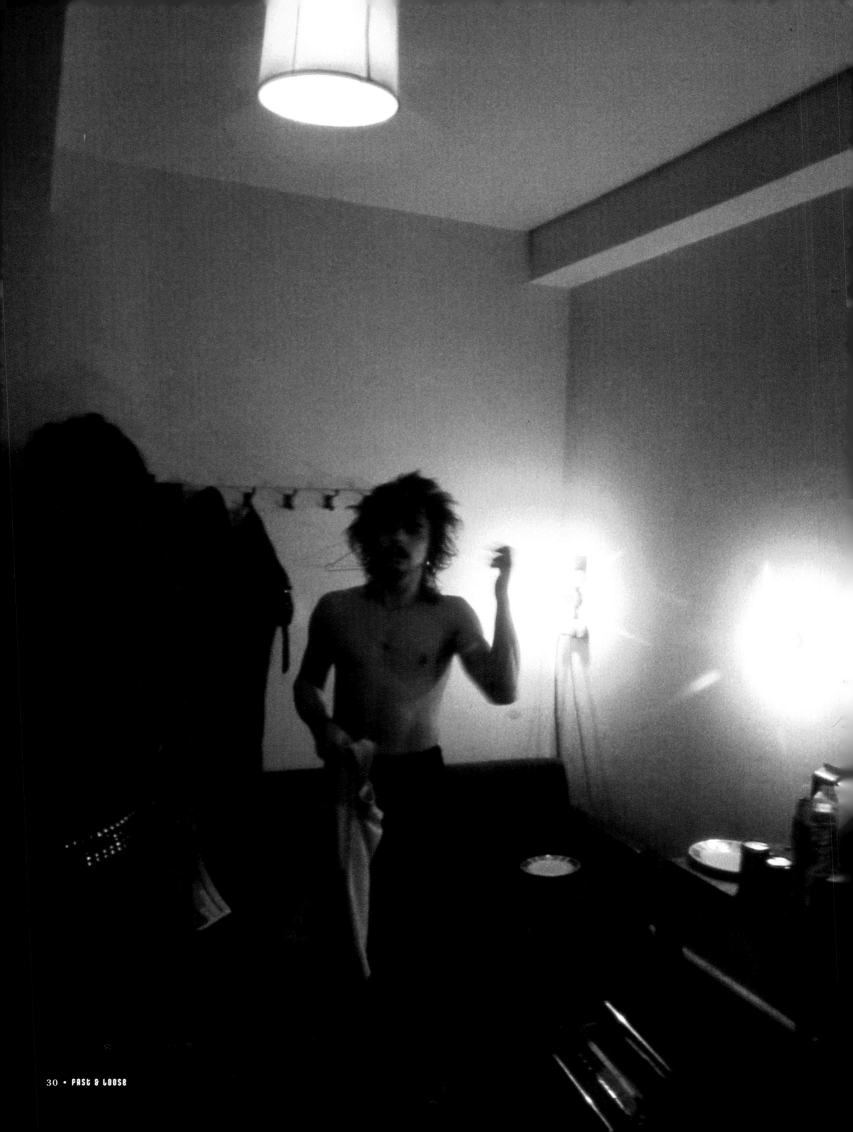

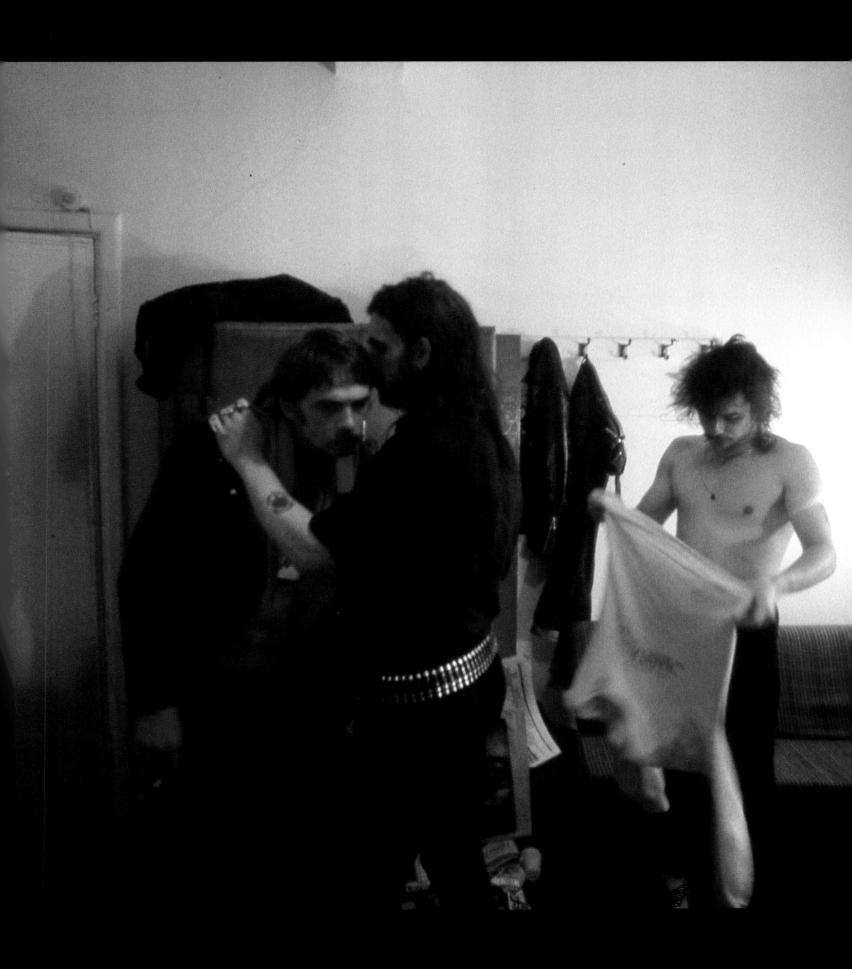

Peter Cook and Dudley Moore went on about "living in a matchbox," and this is Philthy emulating that using a dressing room closet!

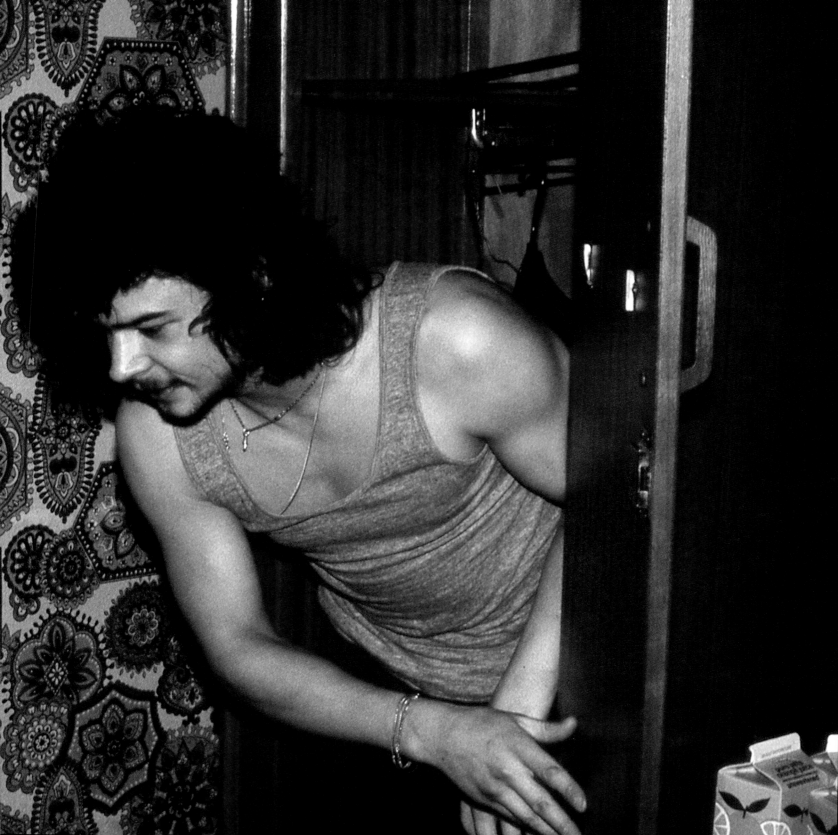

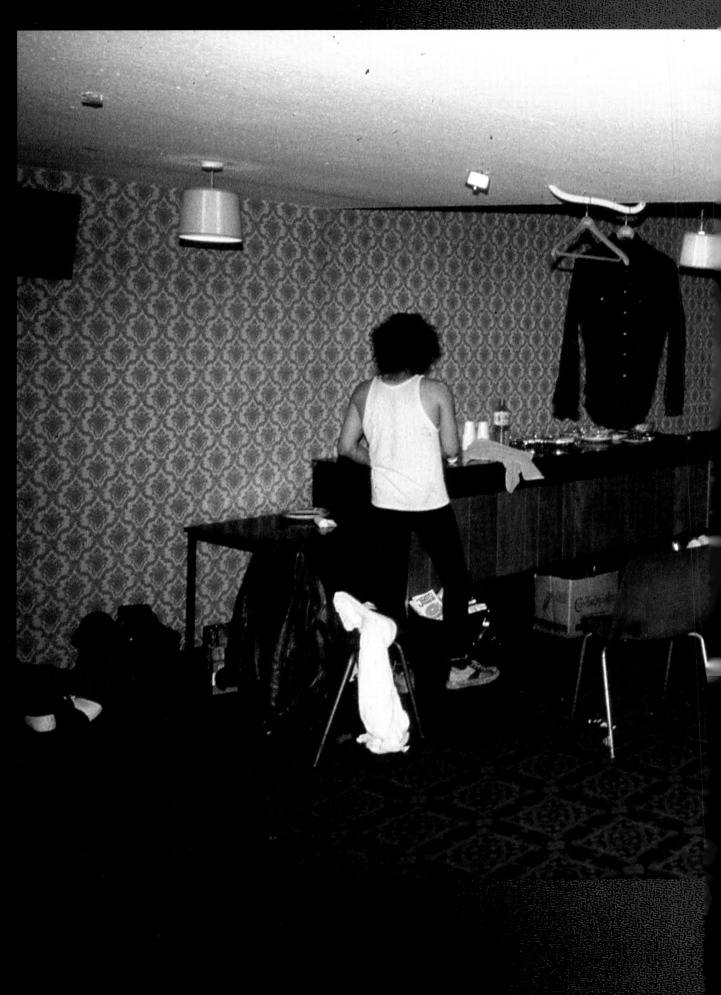

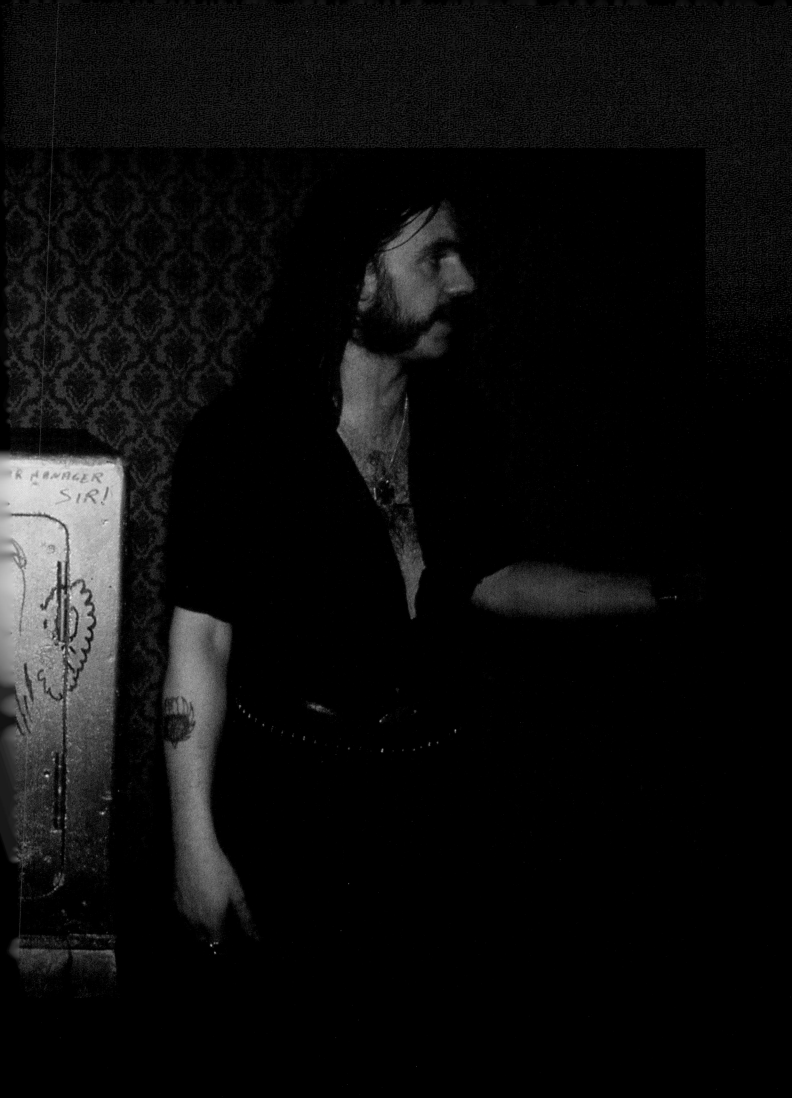

37

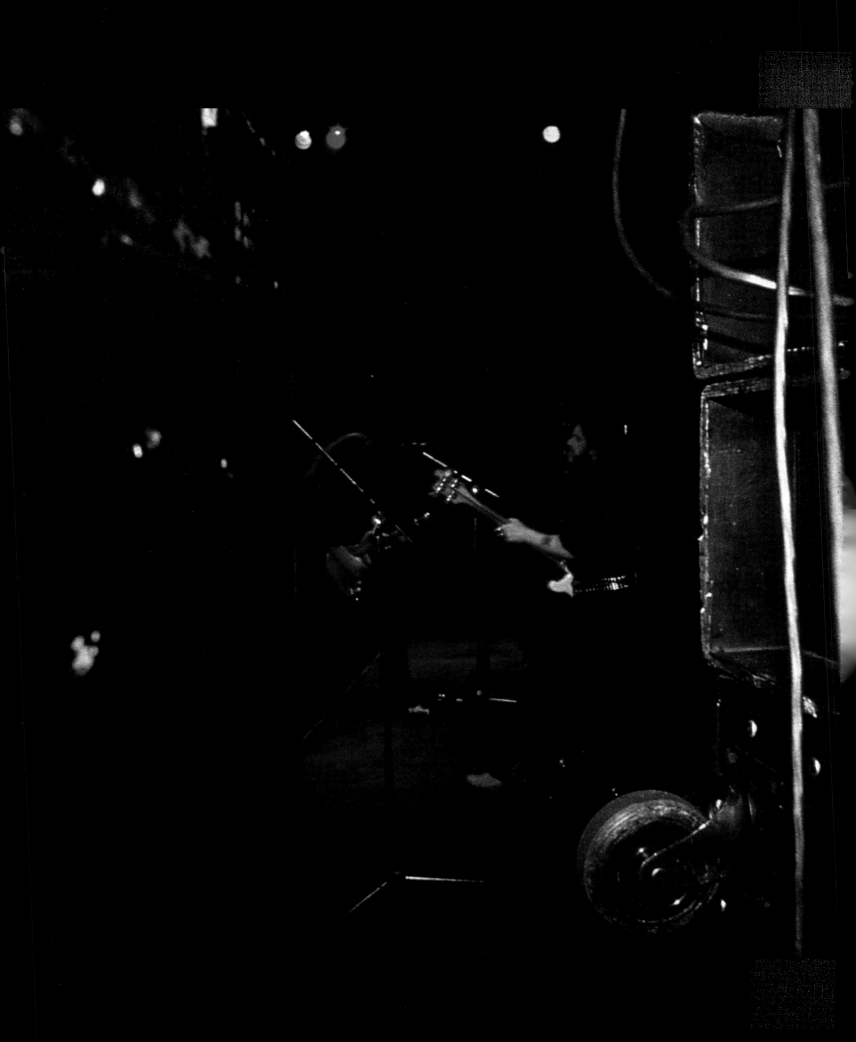

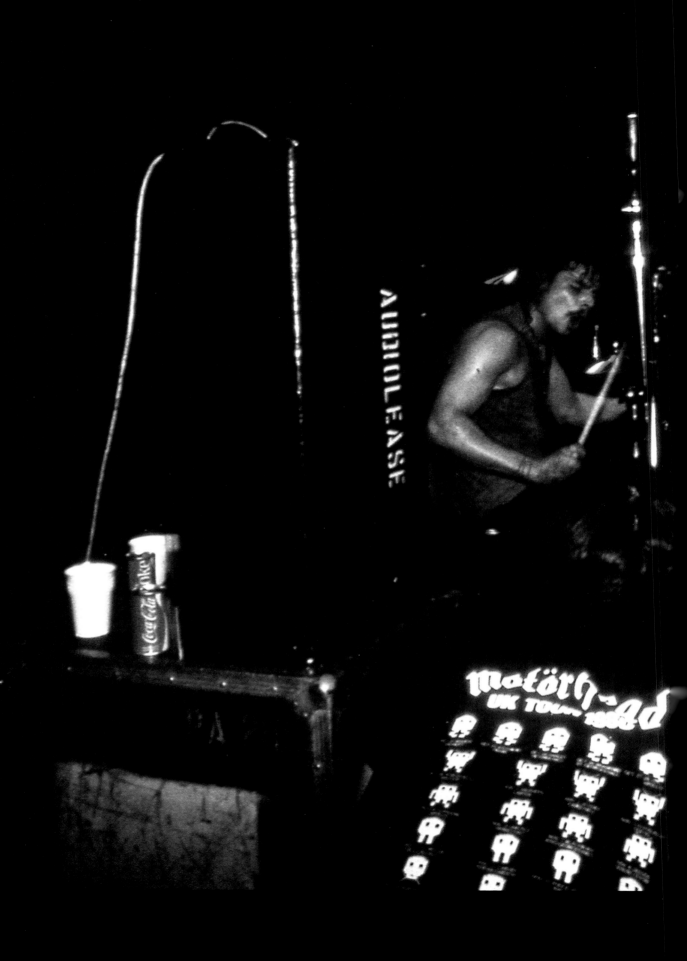

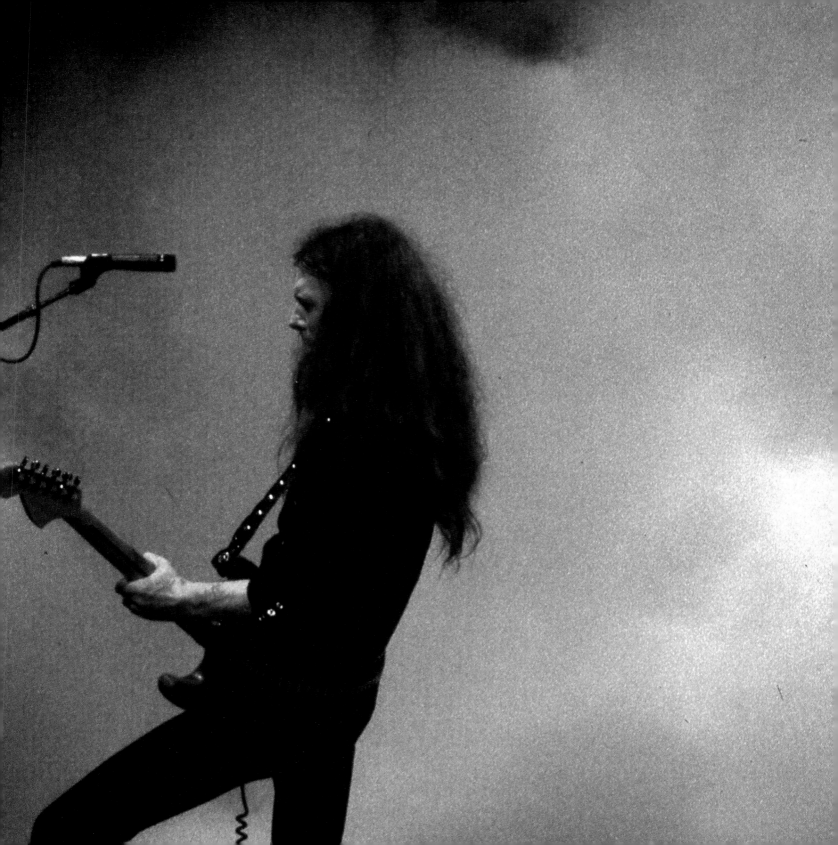

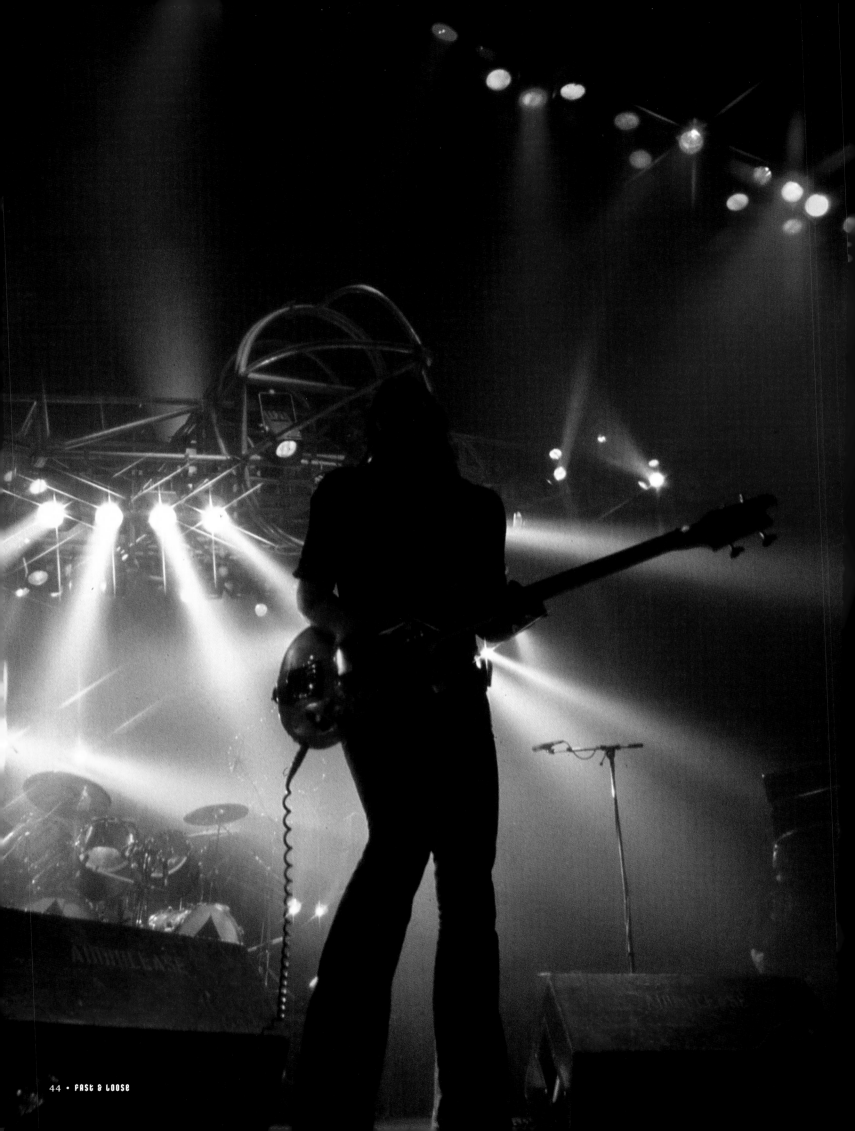

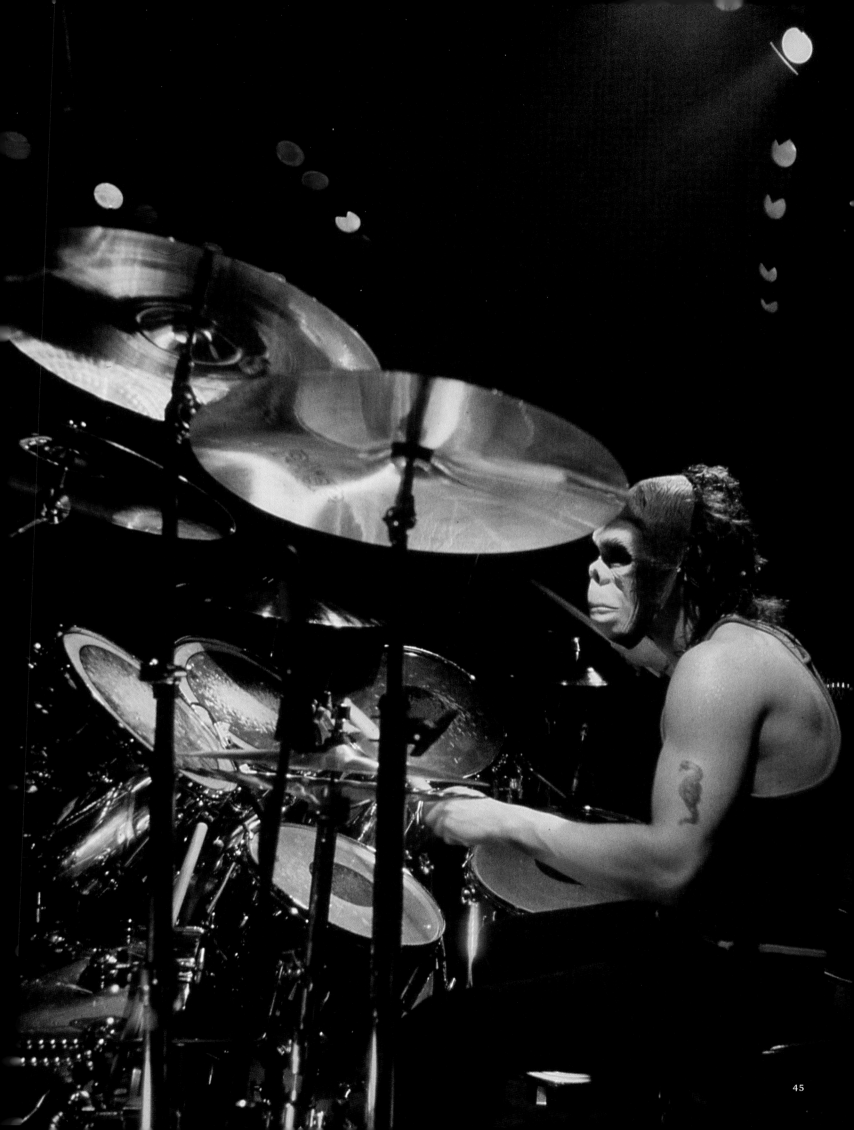

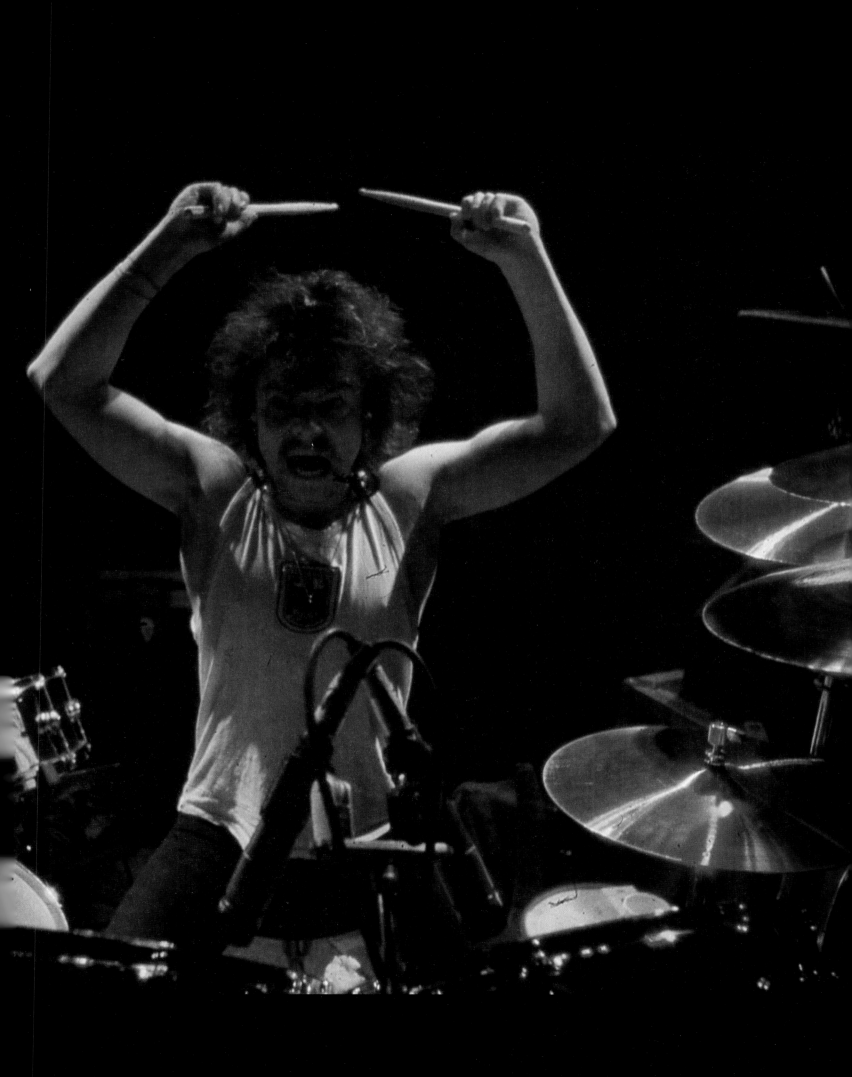

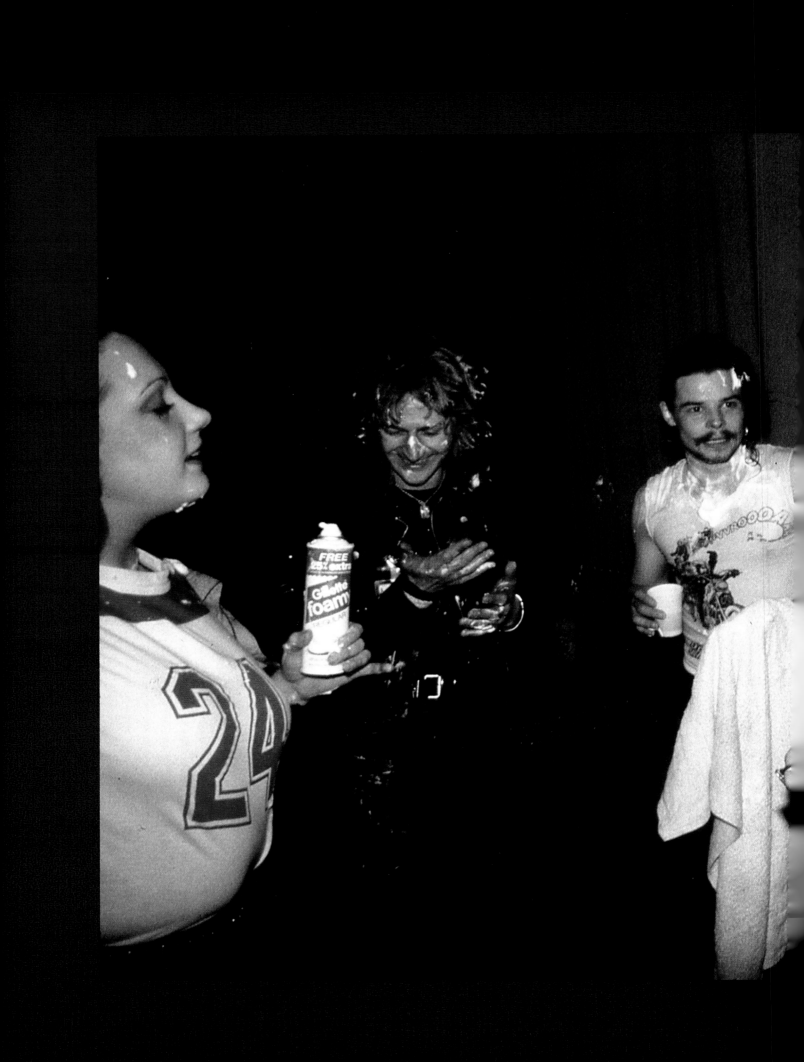

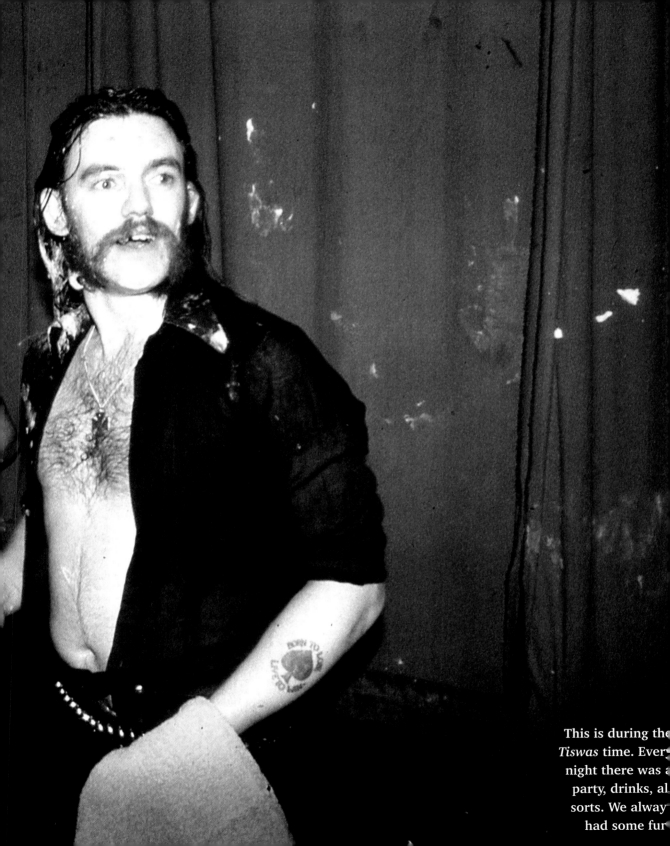

This is during the
Tiswas time. Ever
night there was a
party, drinks, al
sorts. We alway
had some fu

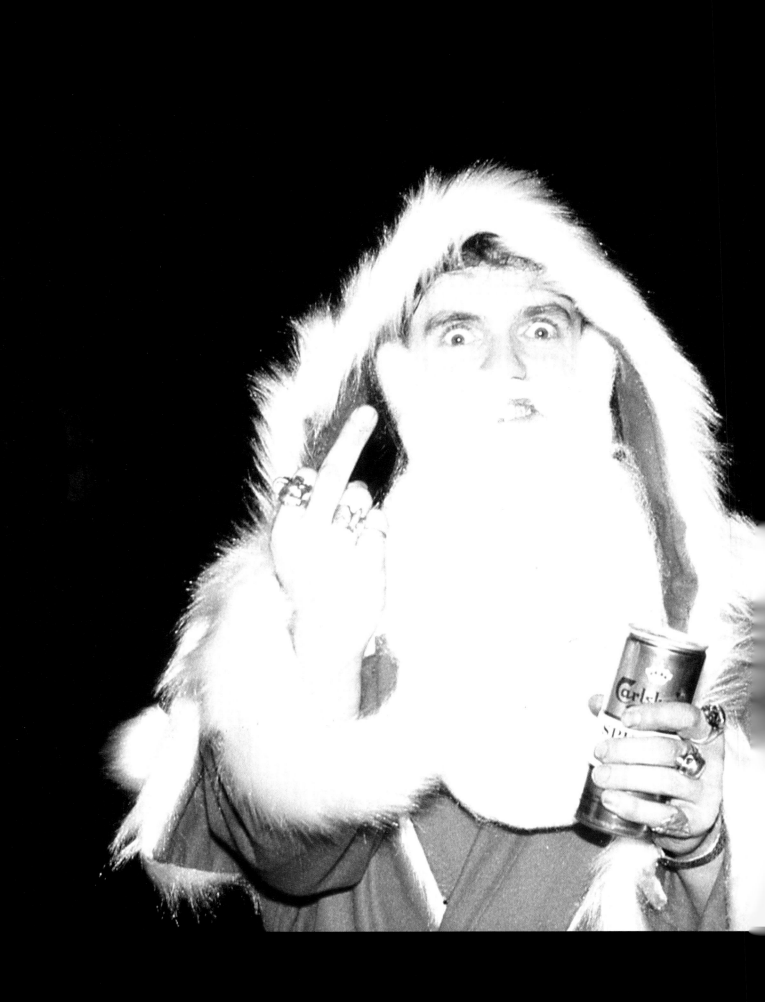

51

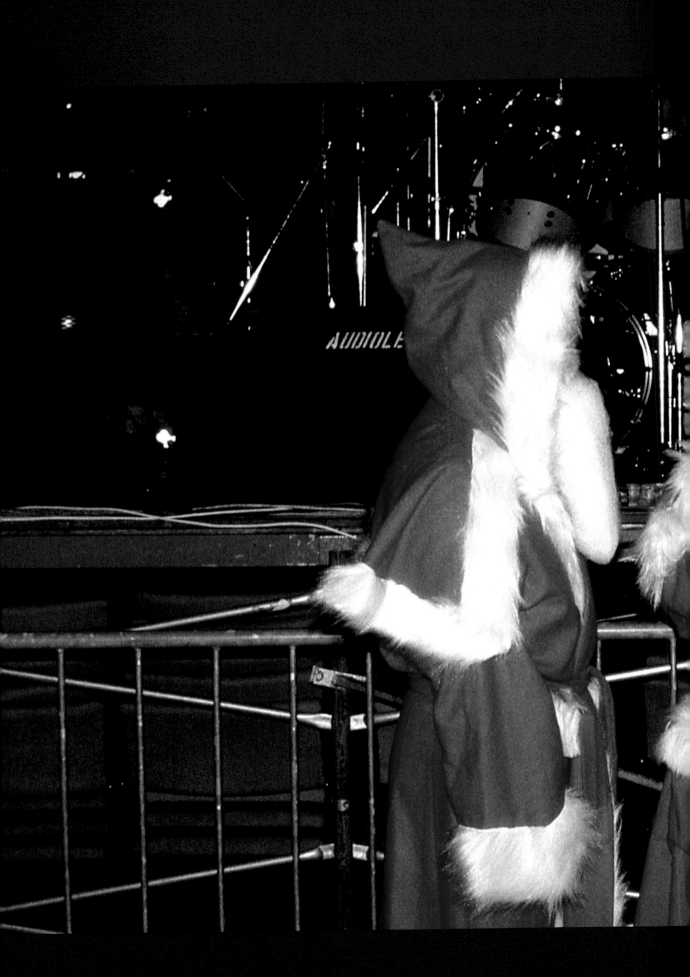

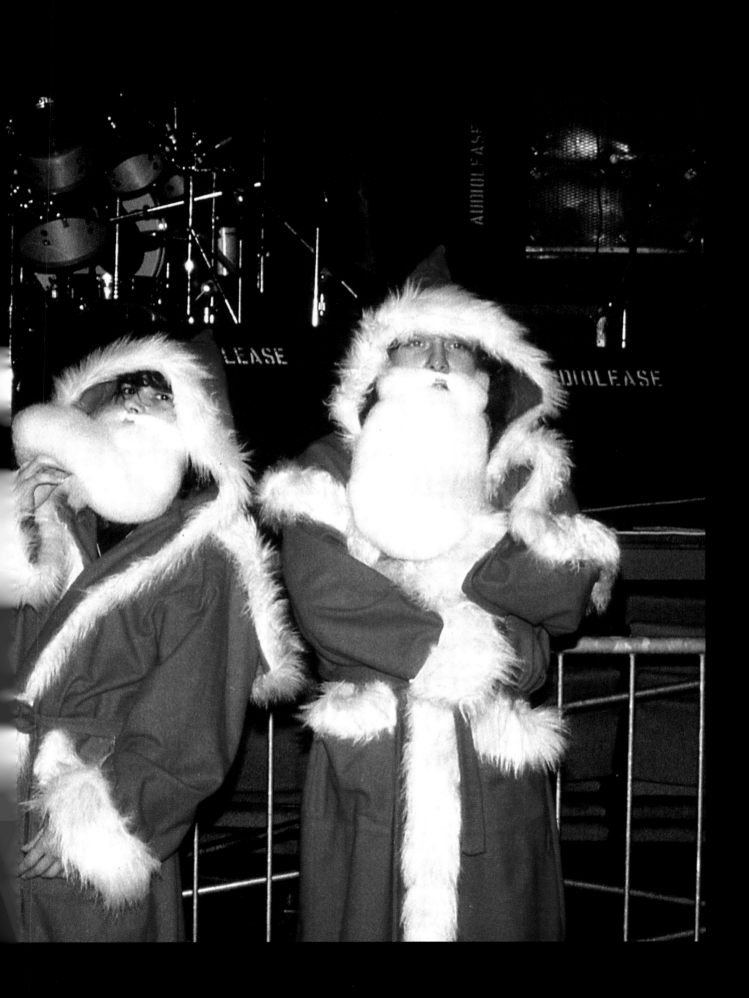

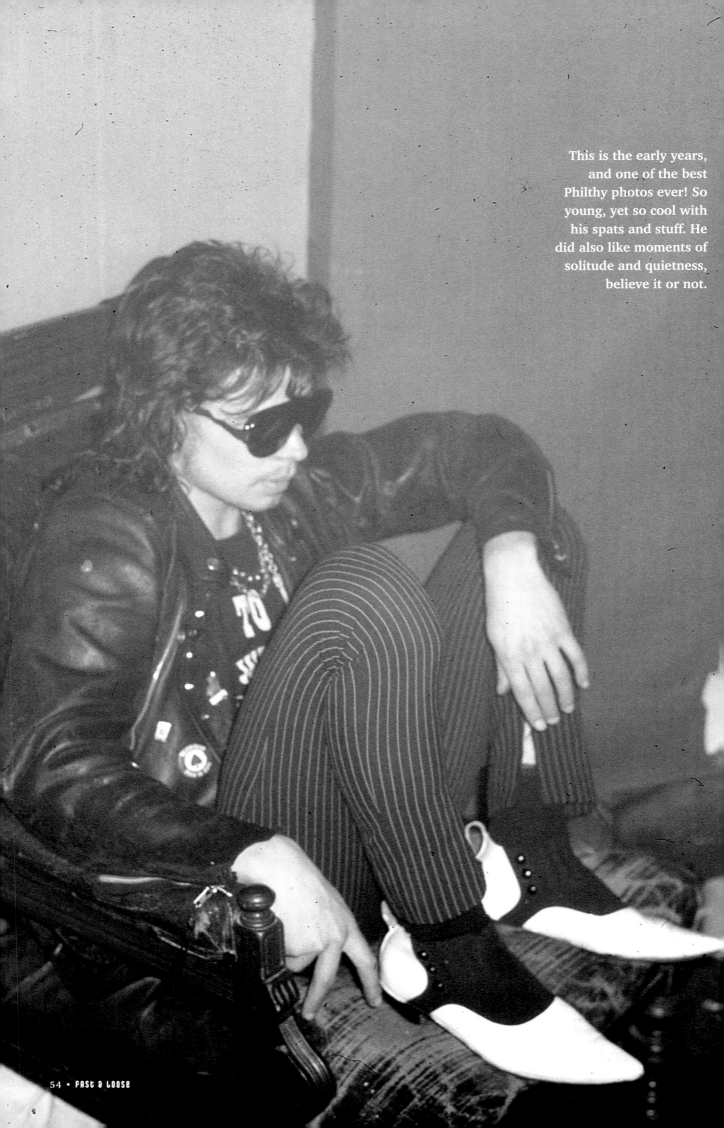

This is the early years, and one of the best Philthy photos ever! So young, yet so cool with his spats and stuff. He did also like moments of solitude and quietness, believe it or not.

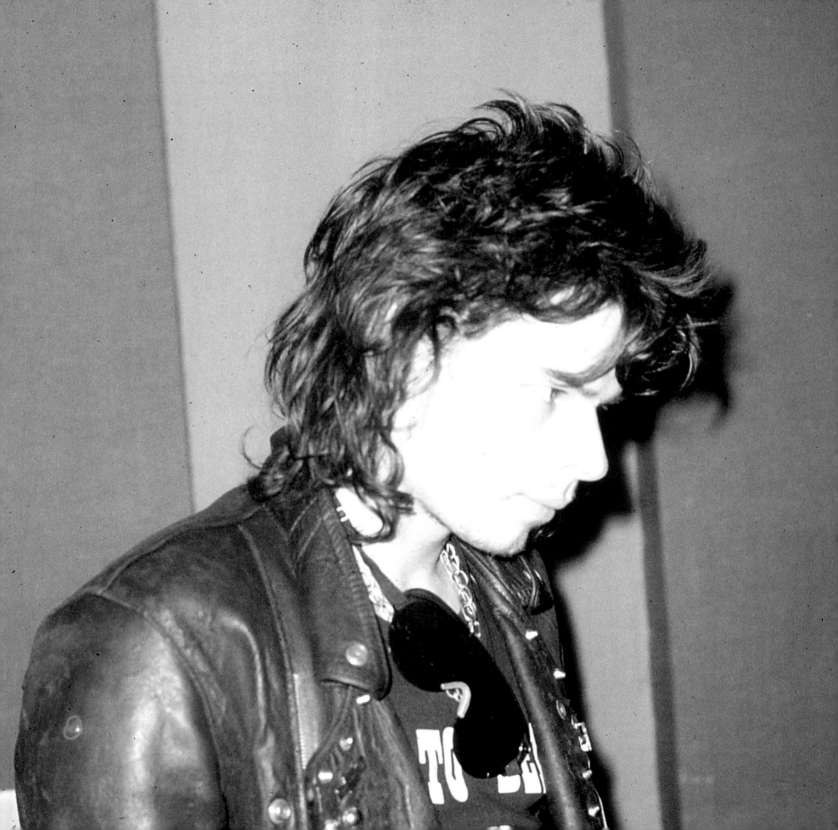

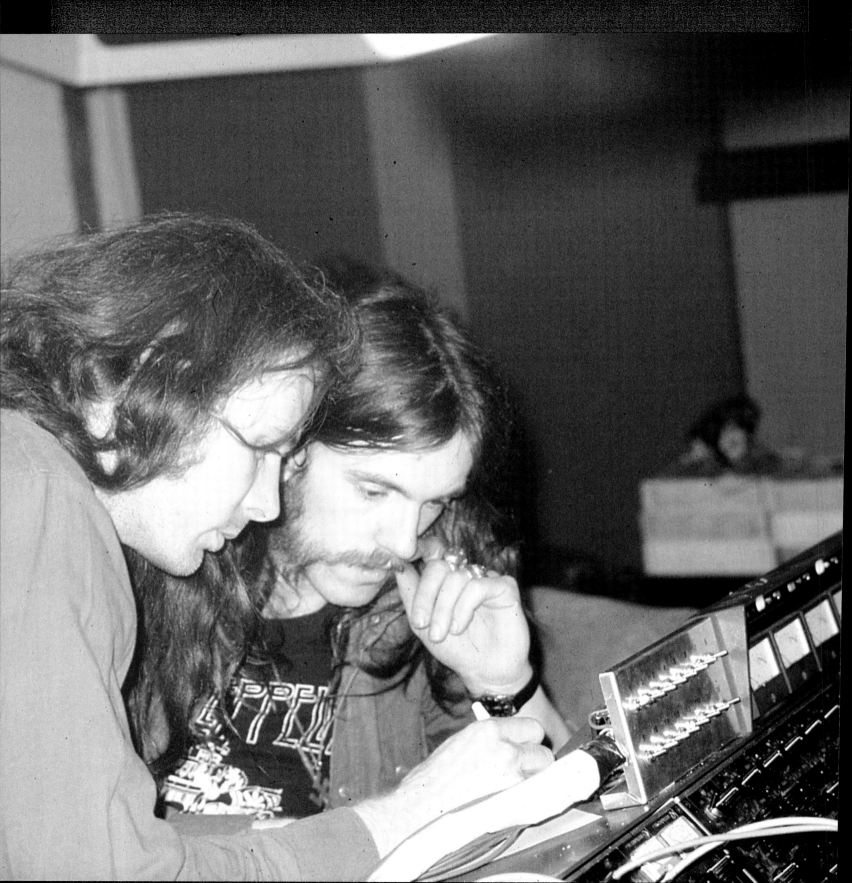

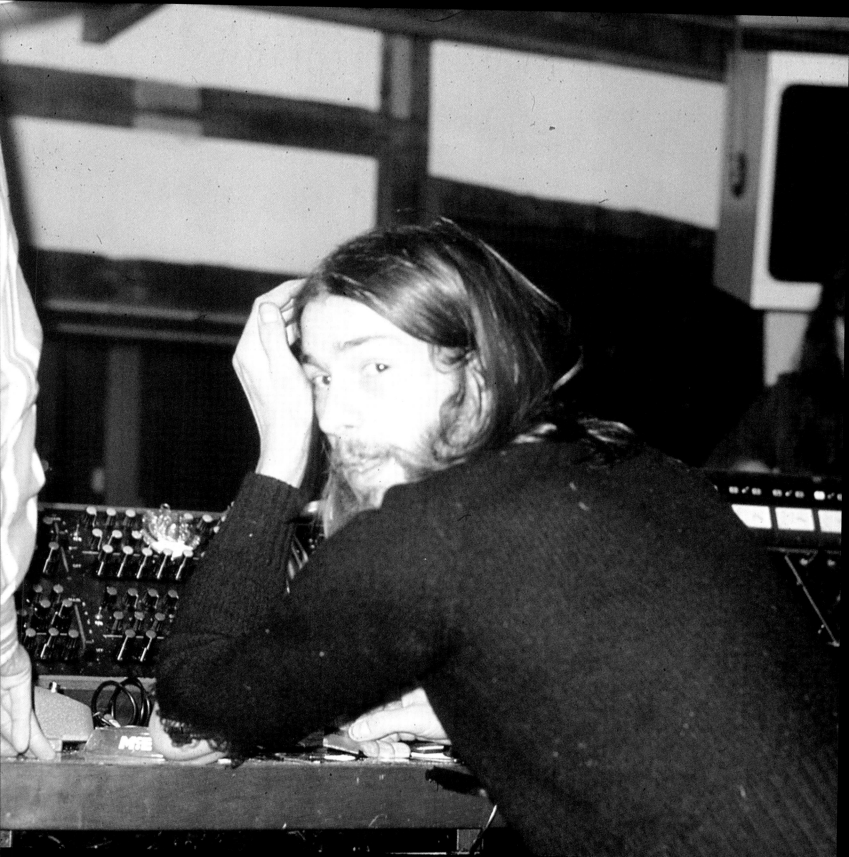

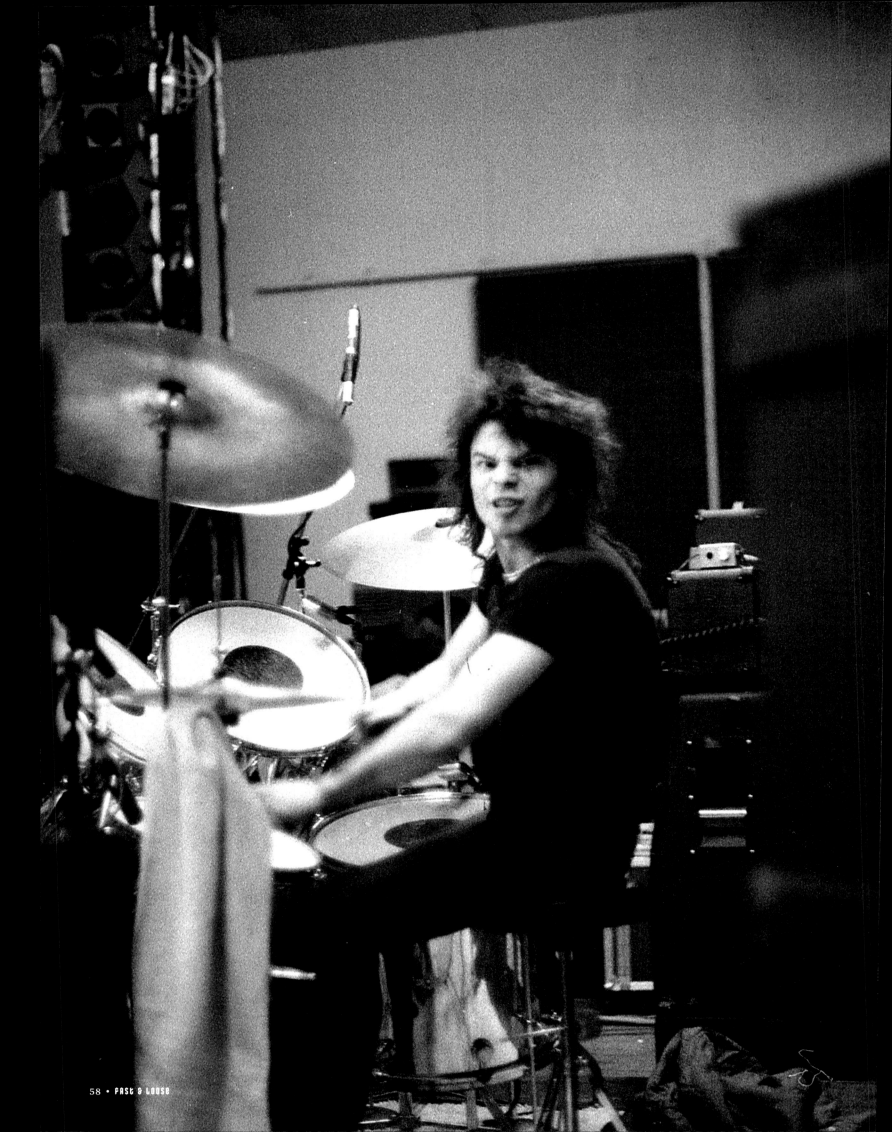

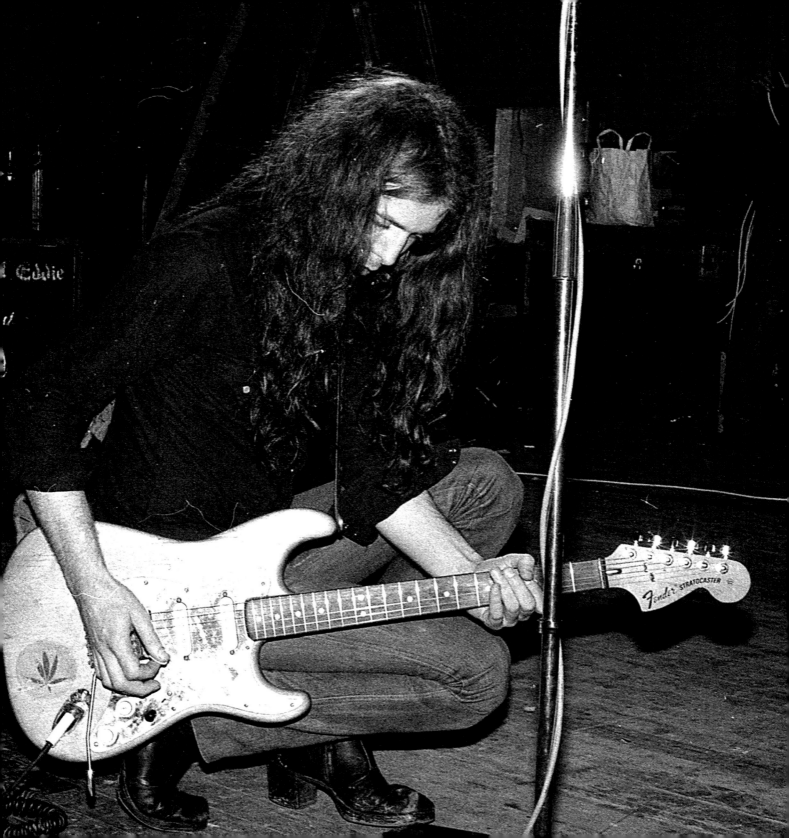

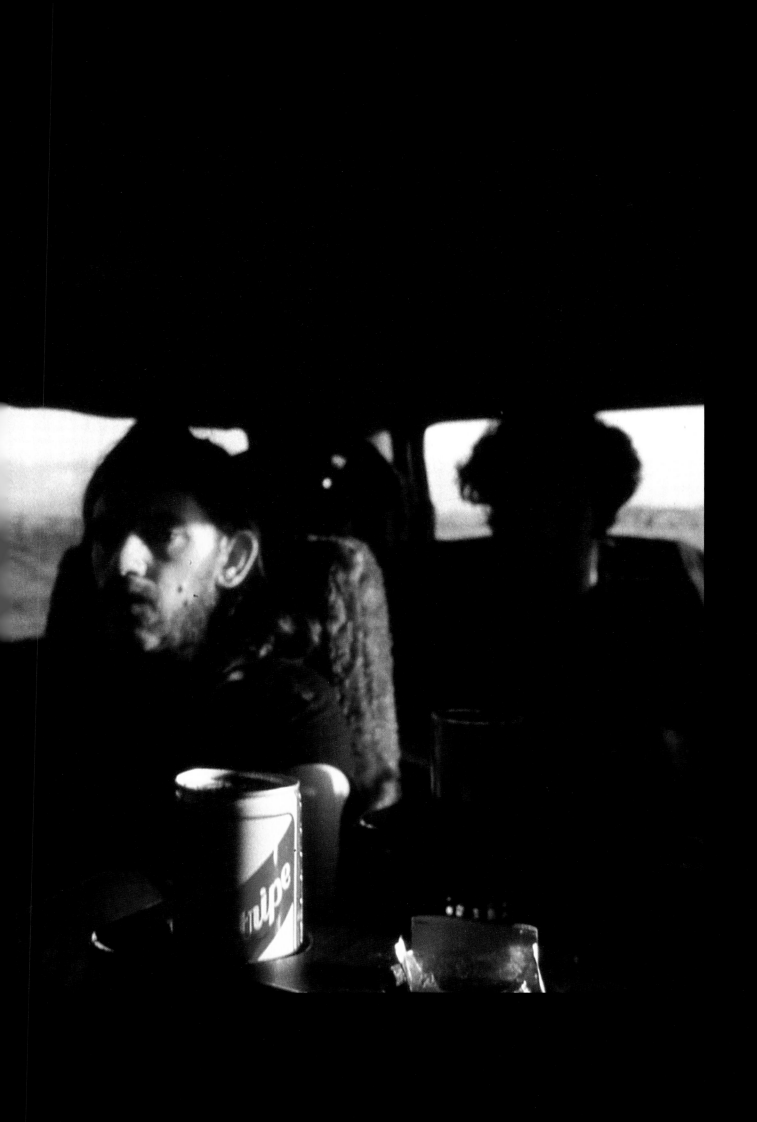

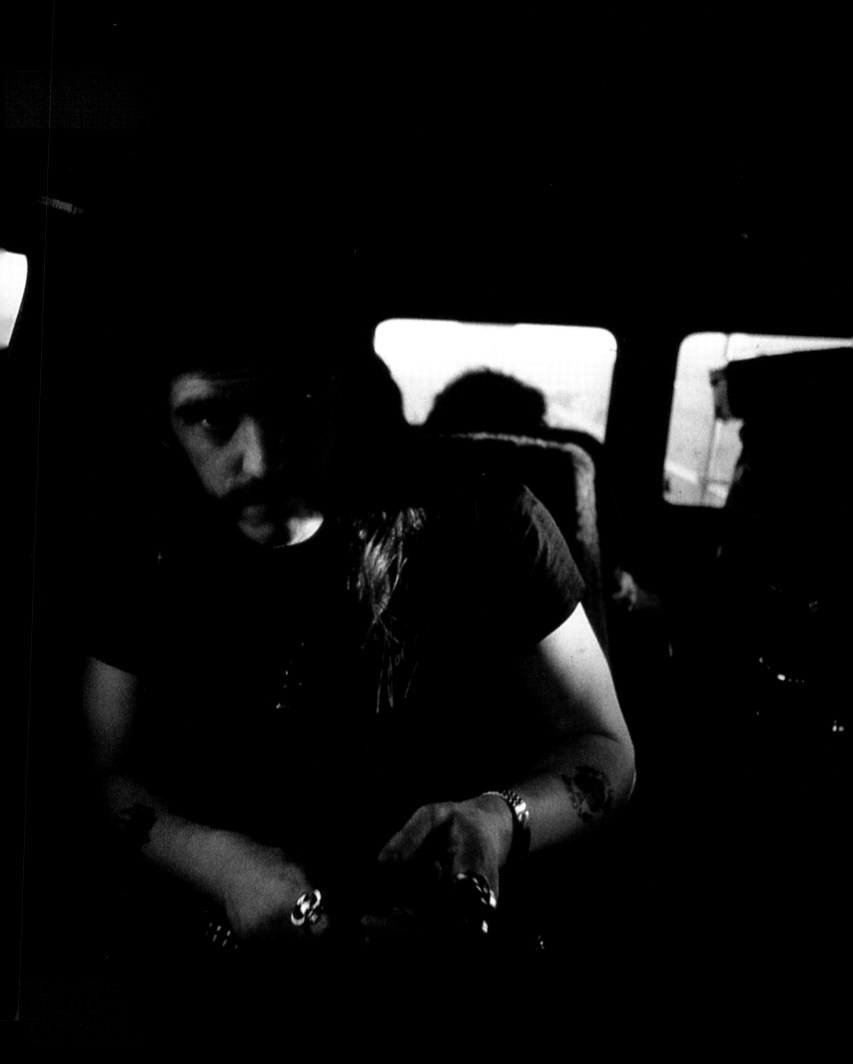

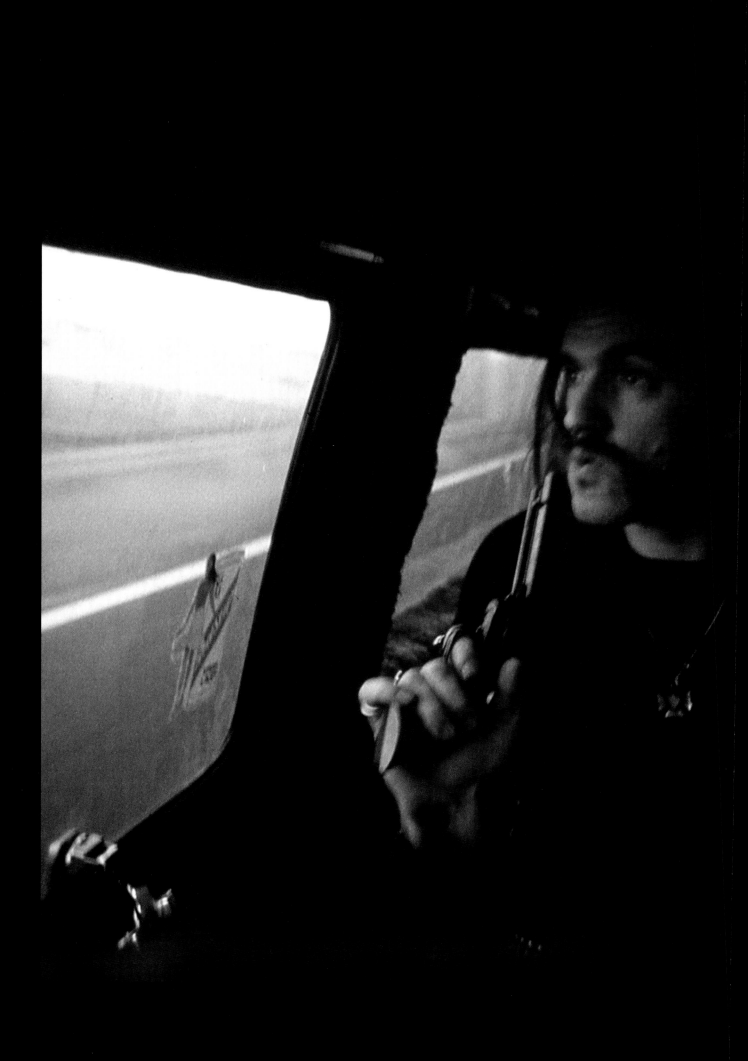

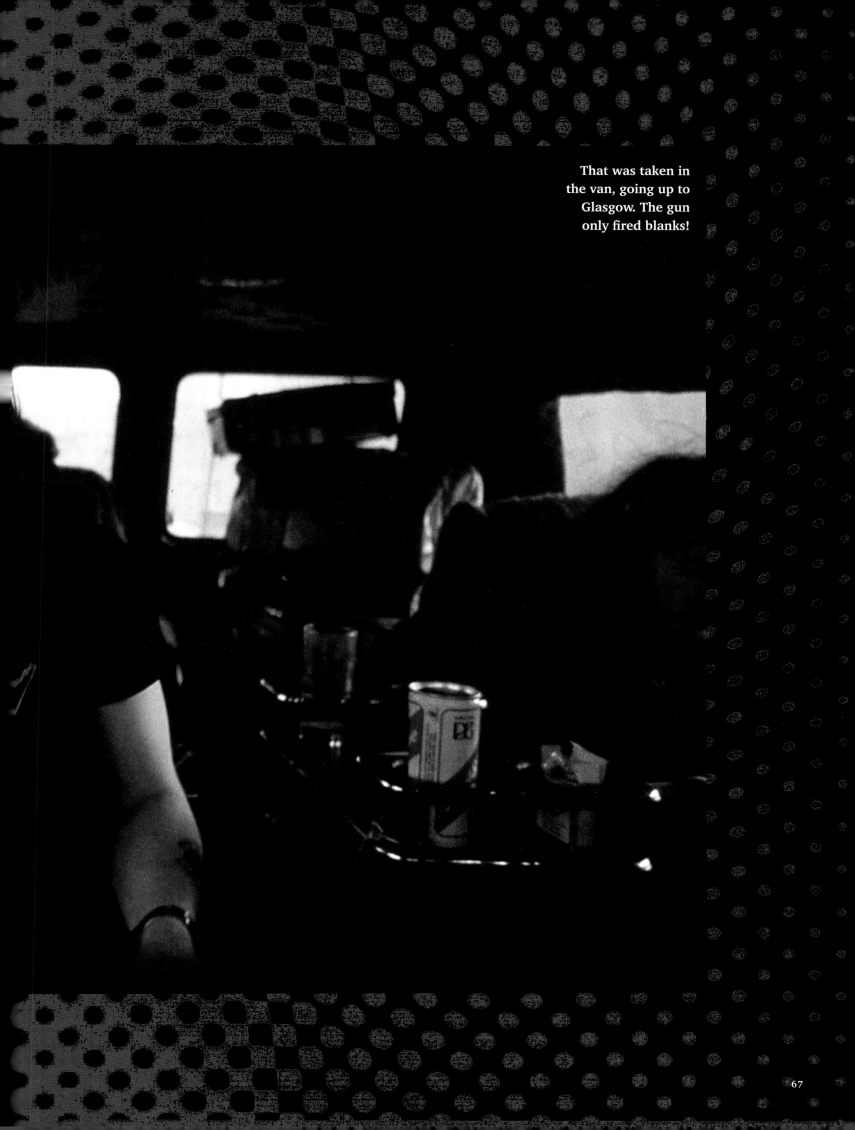

That was taken in
the van, going up to
Glasgow. The gun
only fired blanks!

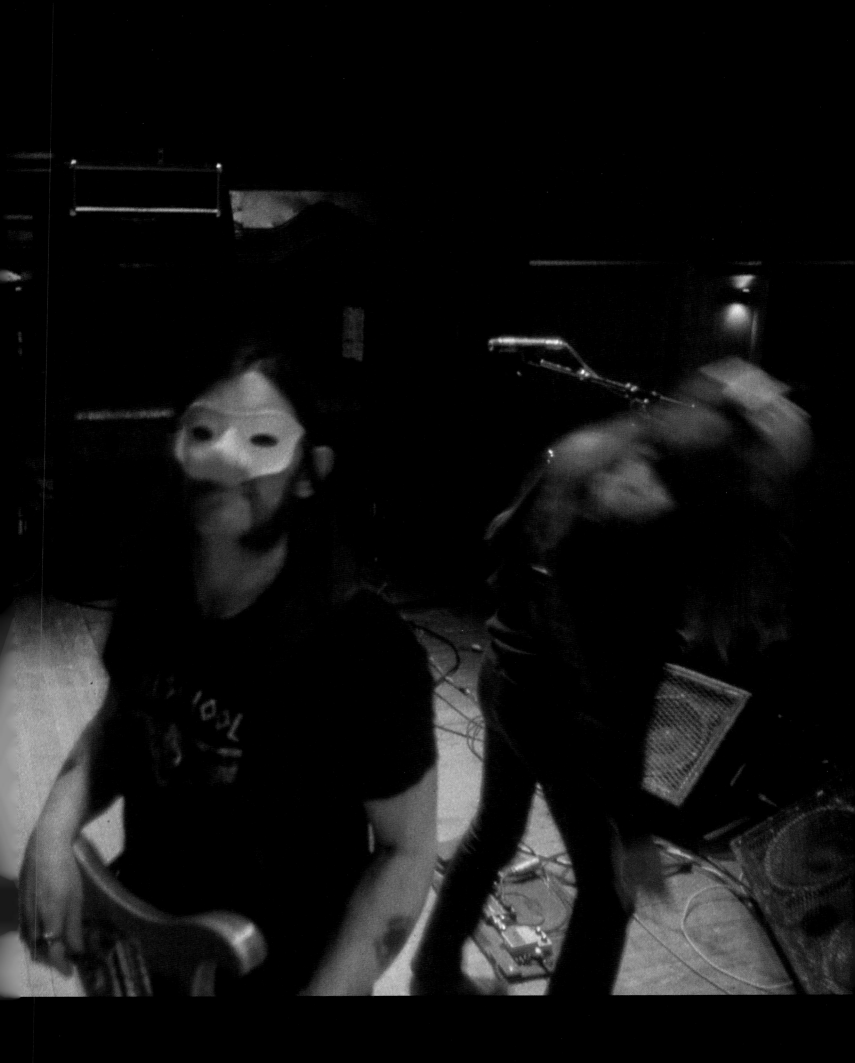

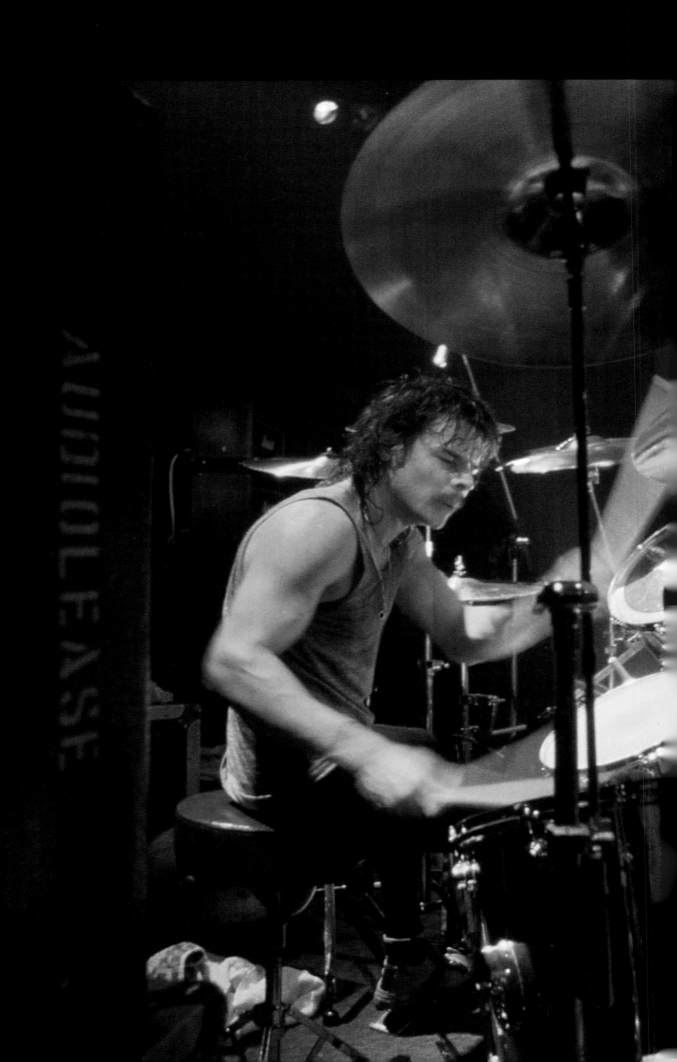

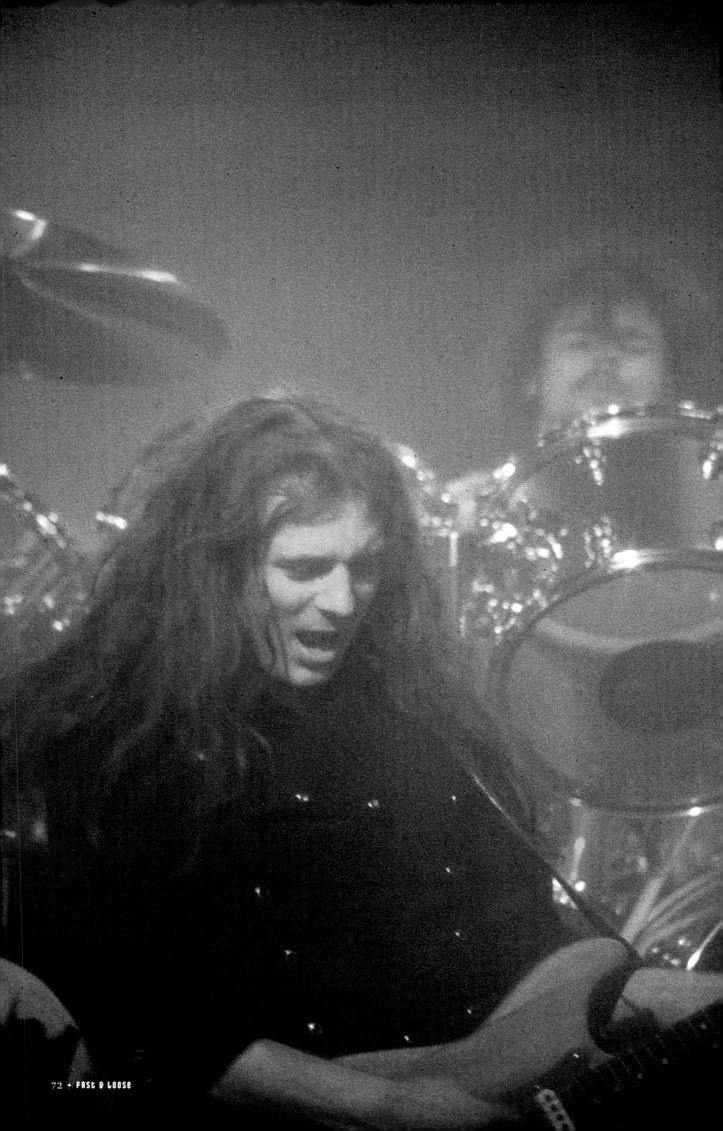

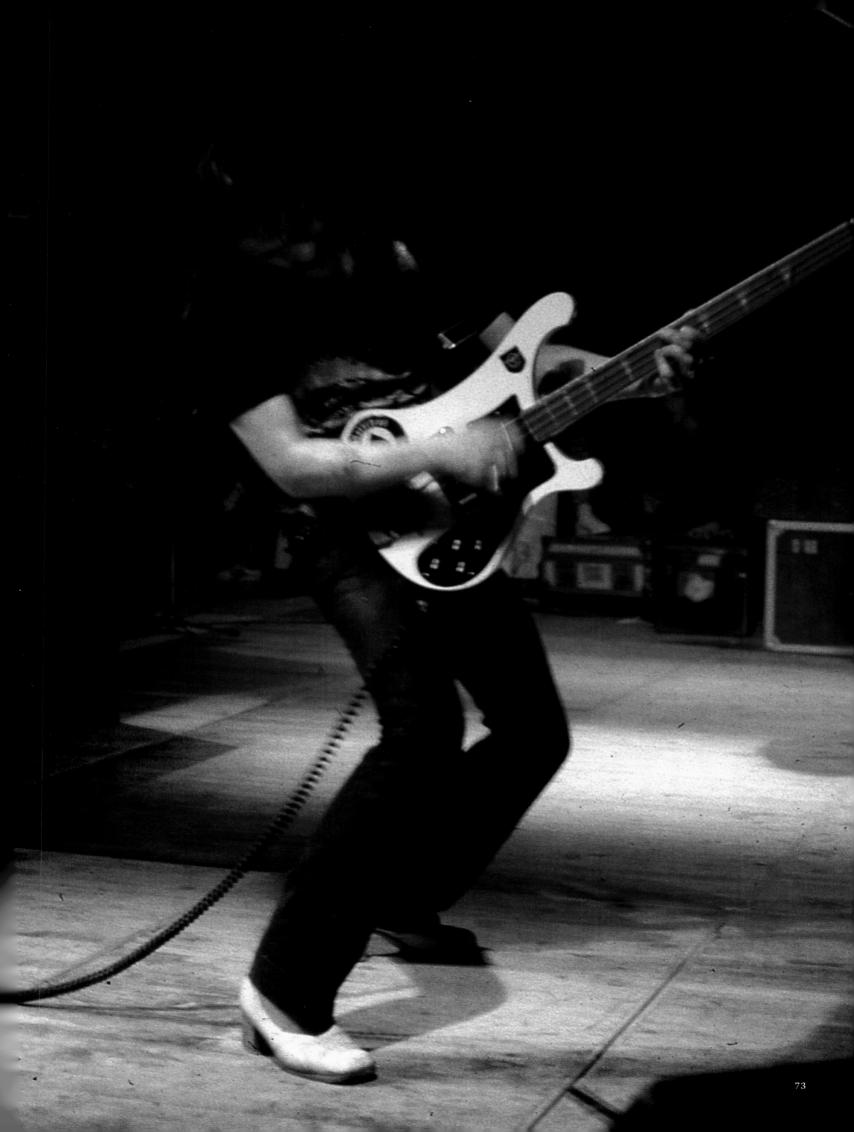

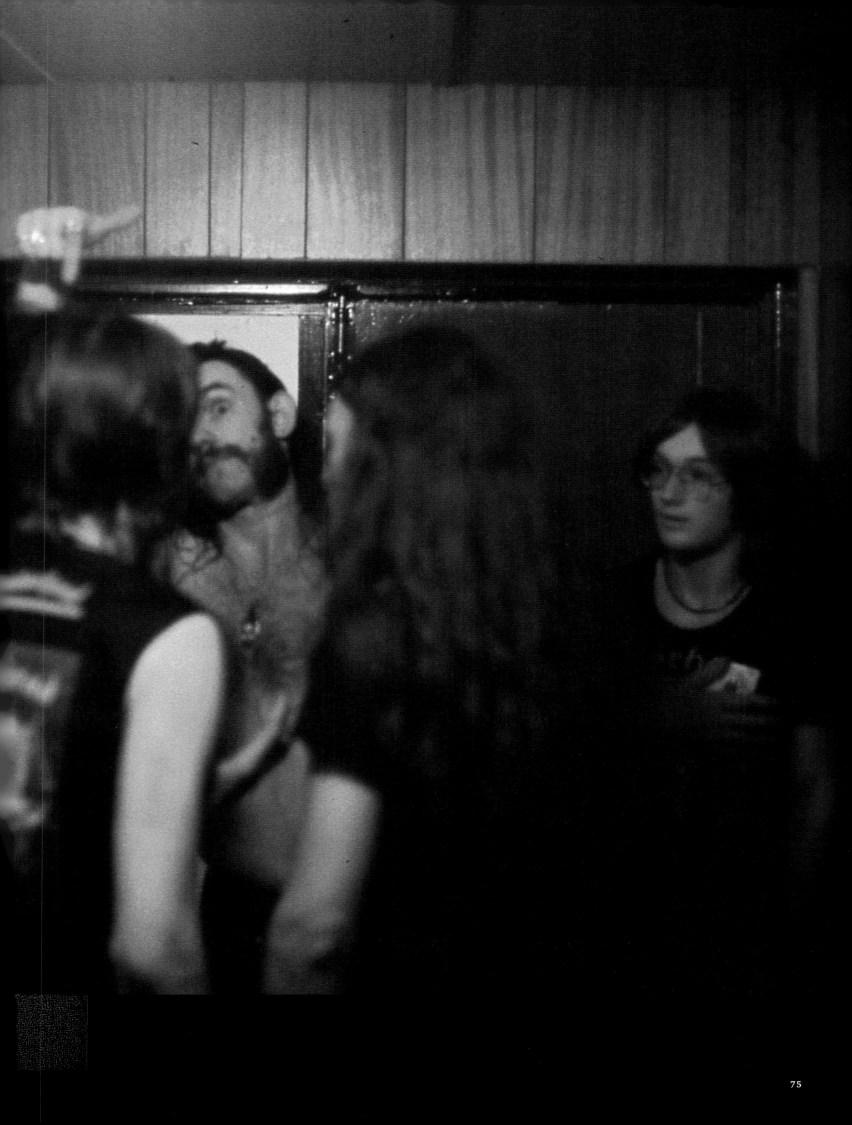

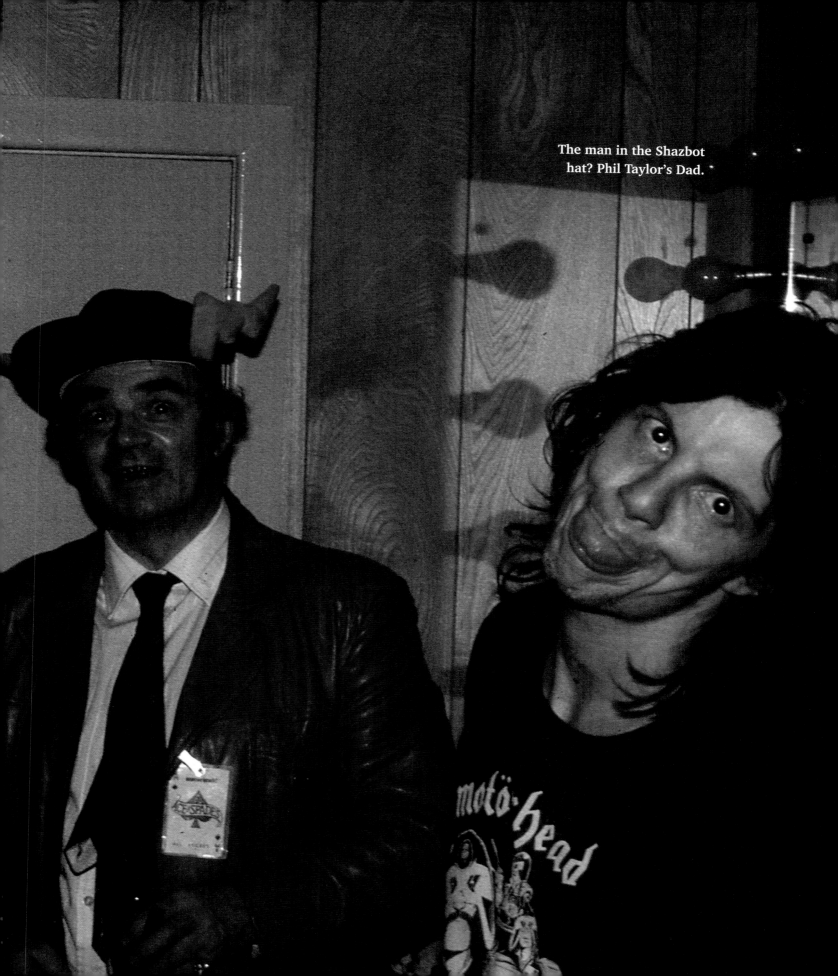

The man in the Shazbot
hat? Phil Taylor's Dad.

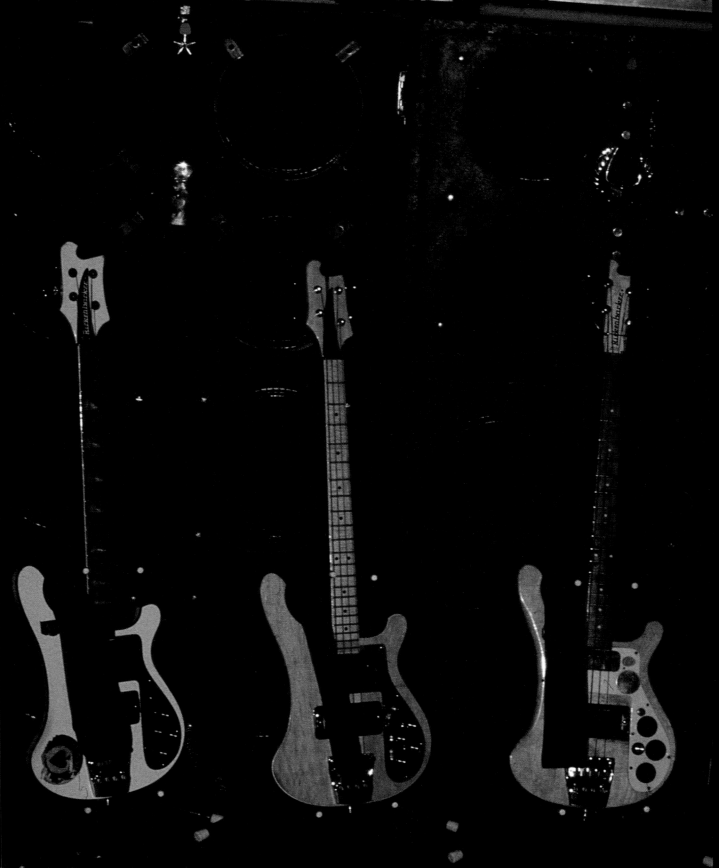

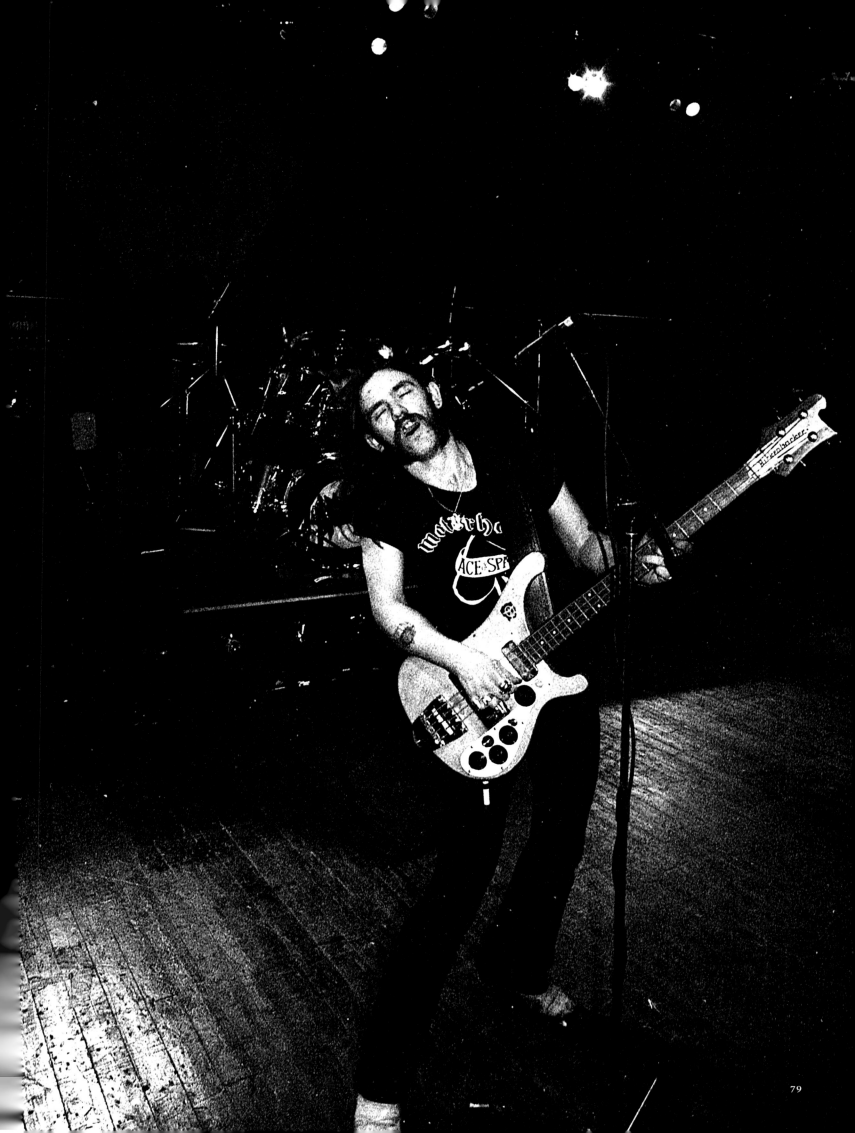

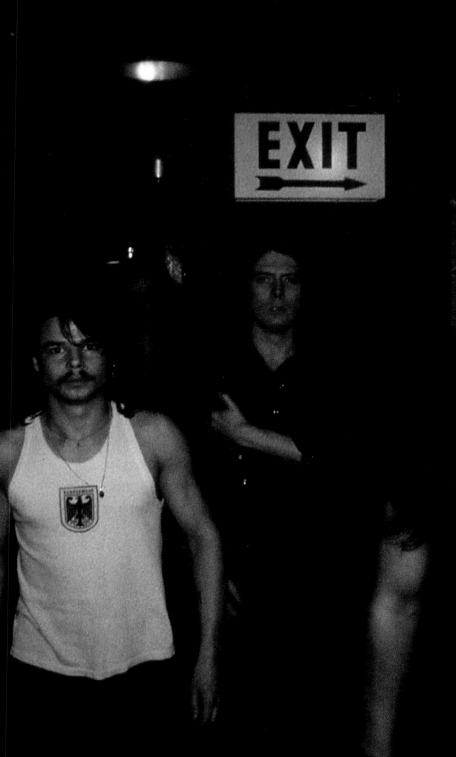

That's two bands on
tour getting together
in the dressing
room, Motörhead
and Weapon. Looks
like Glasgow again...

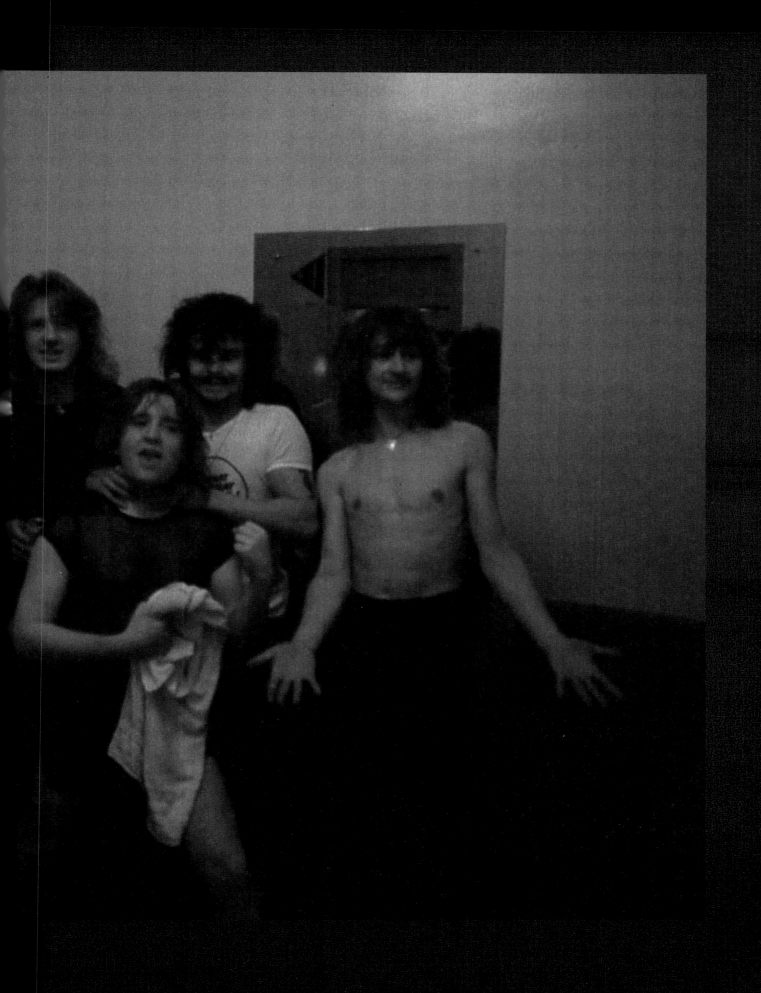

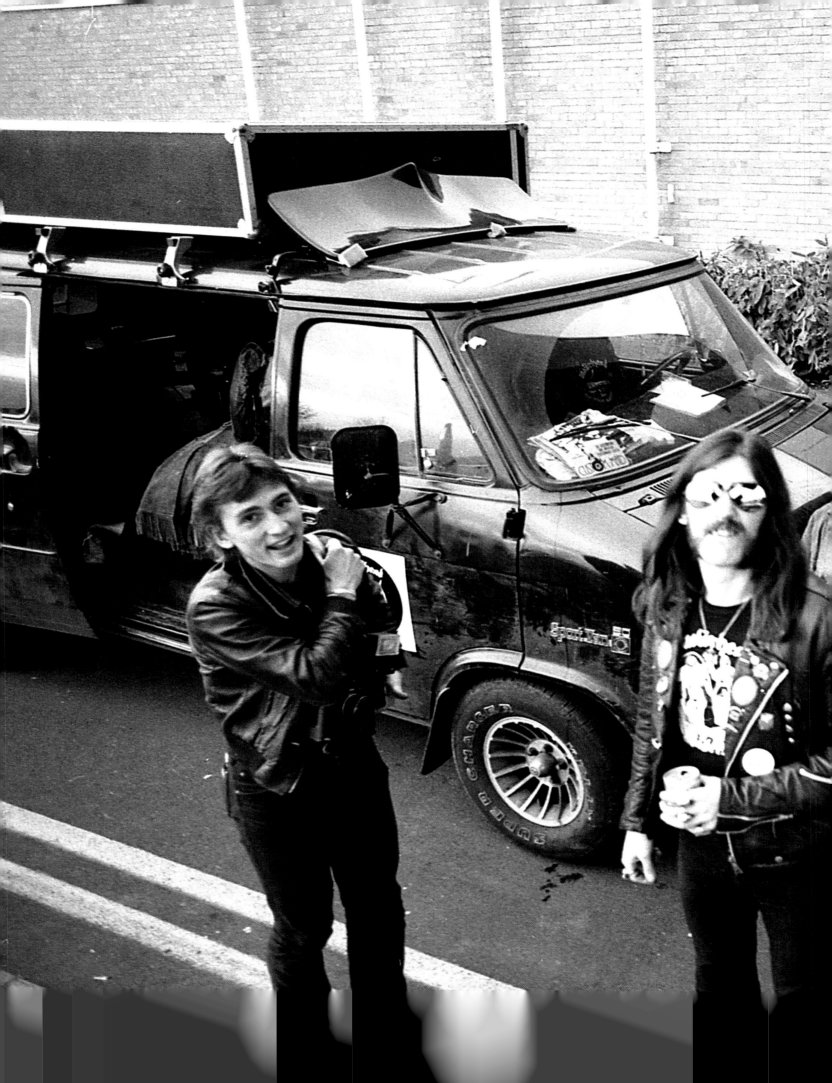

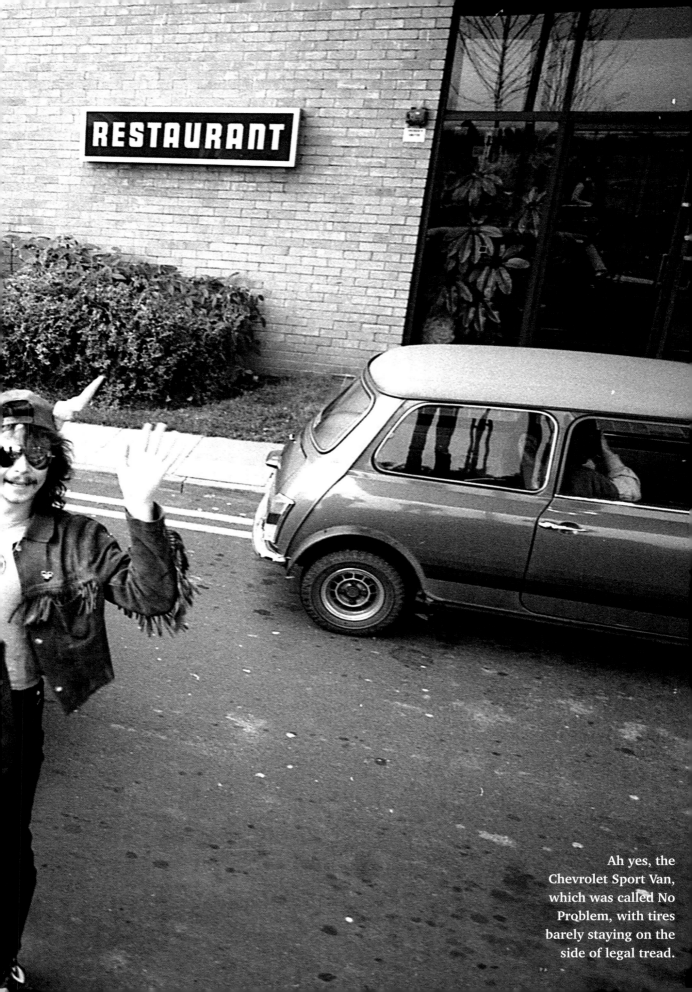

RESTAURANT

Ah yes, the Chevrolet Sport Van, which was called No Problem, with tires barely staying on the side of legal tread.

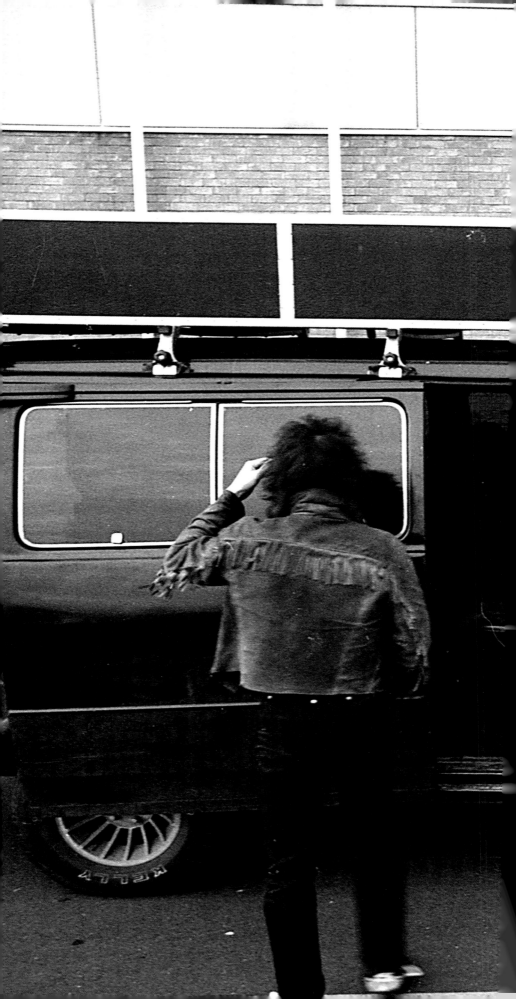

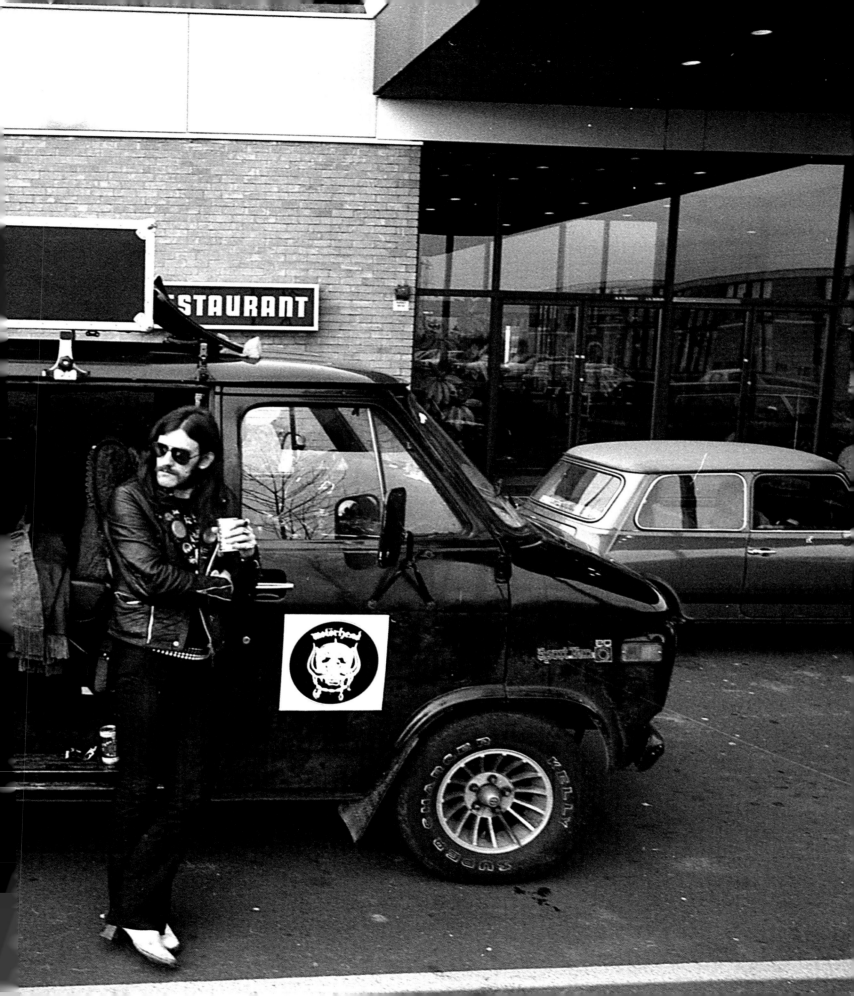

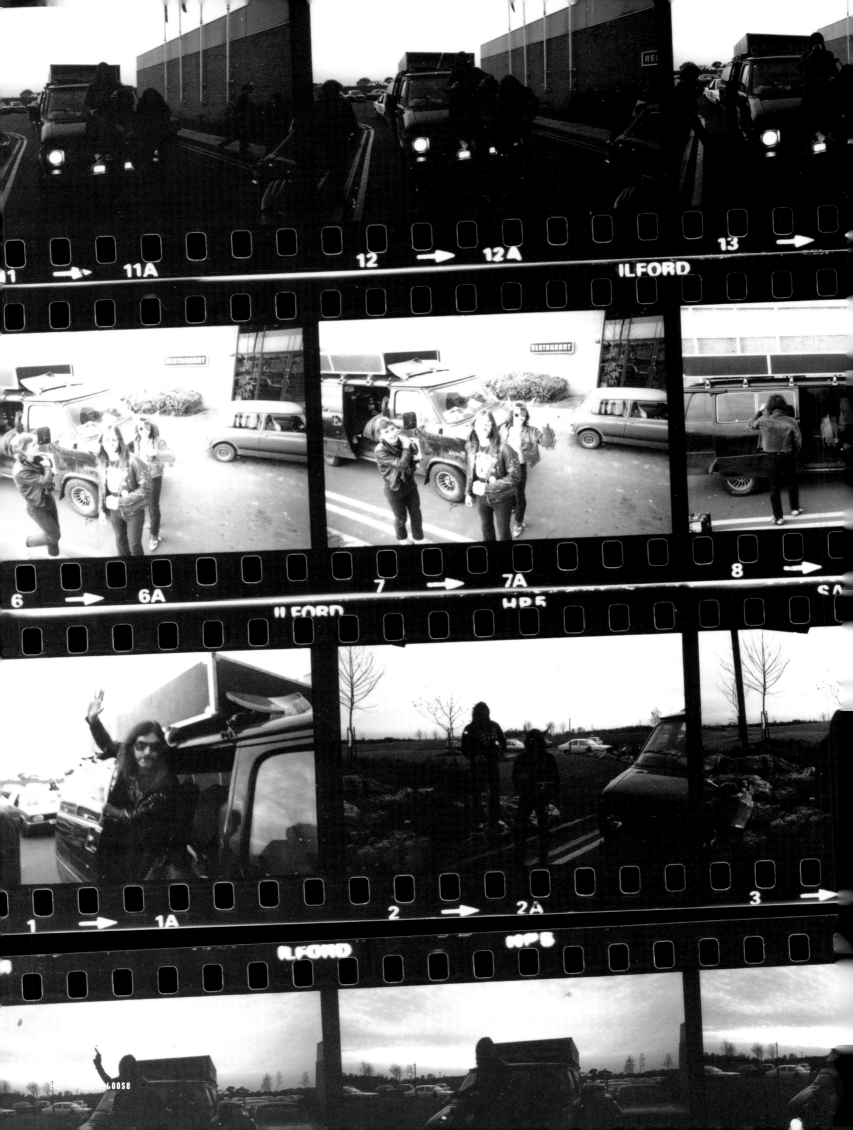

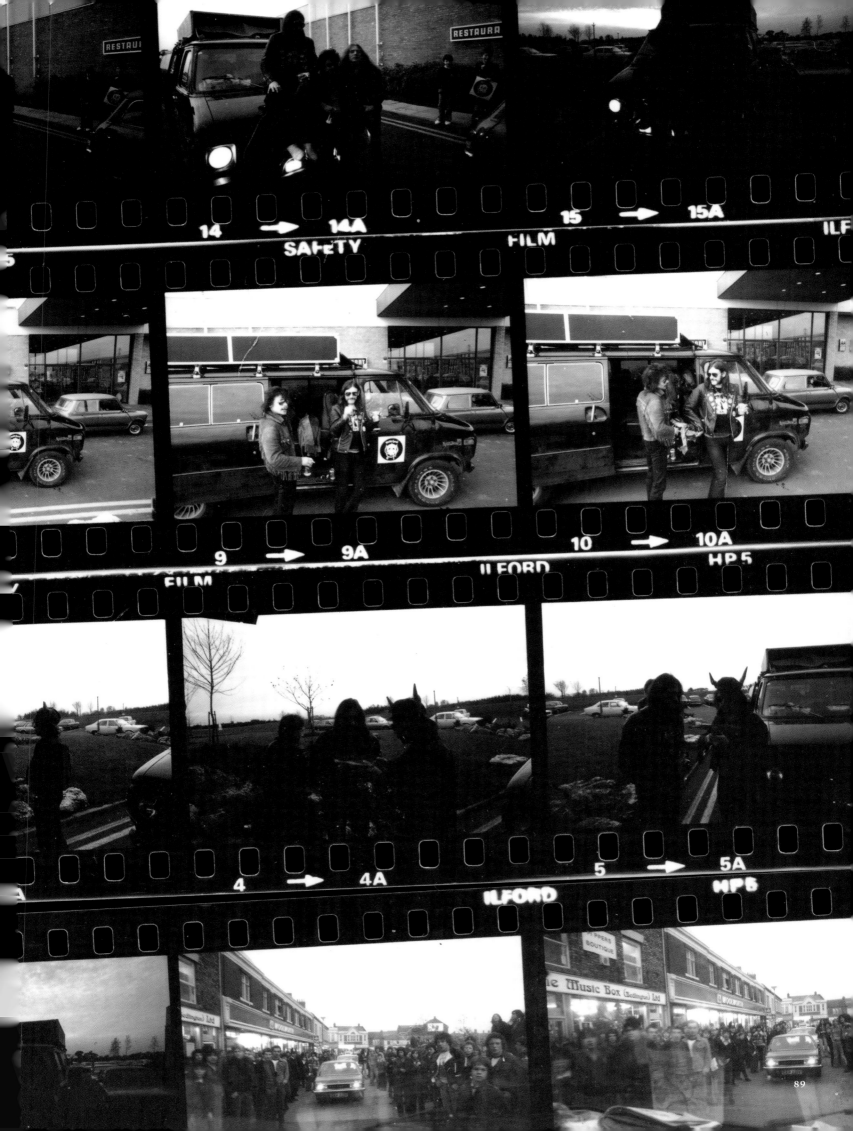

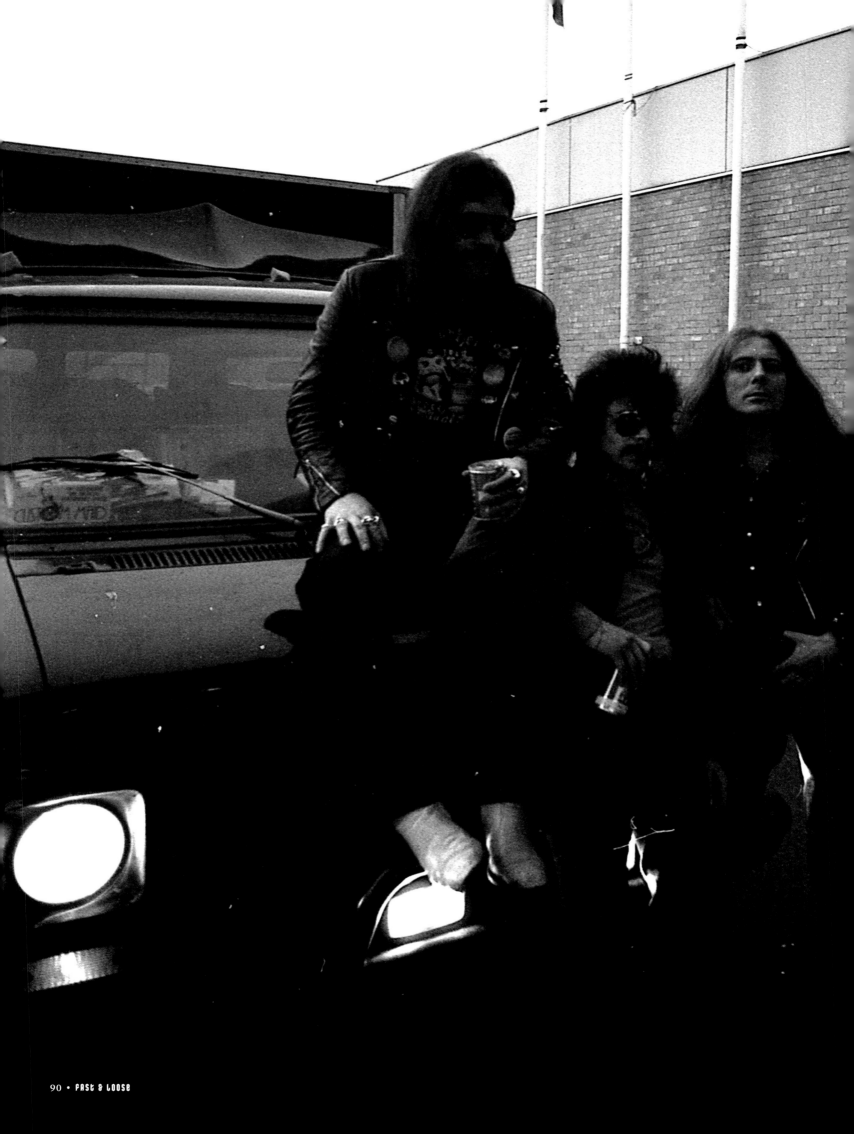

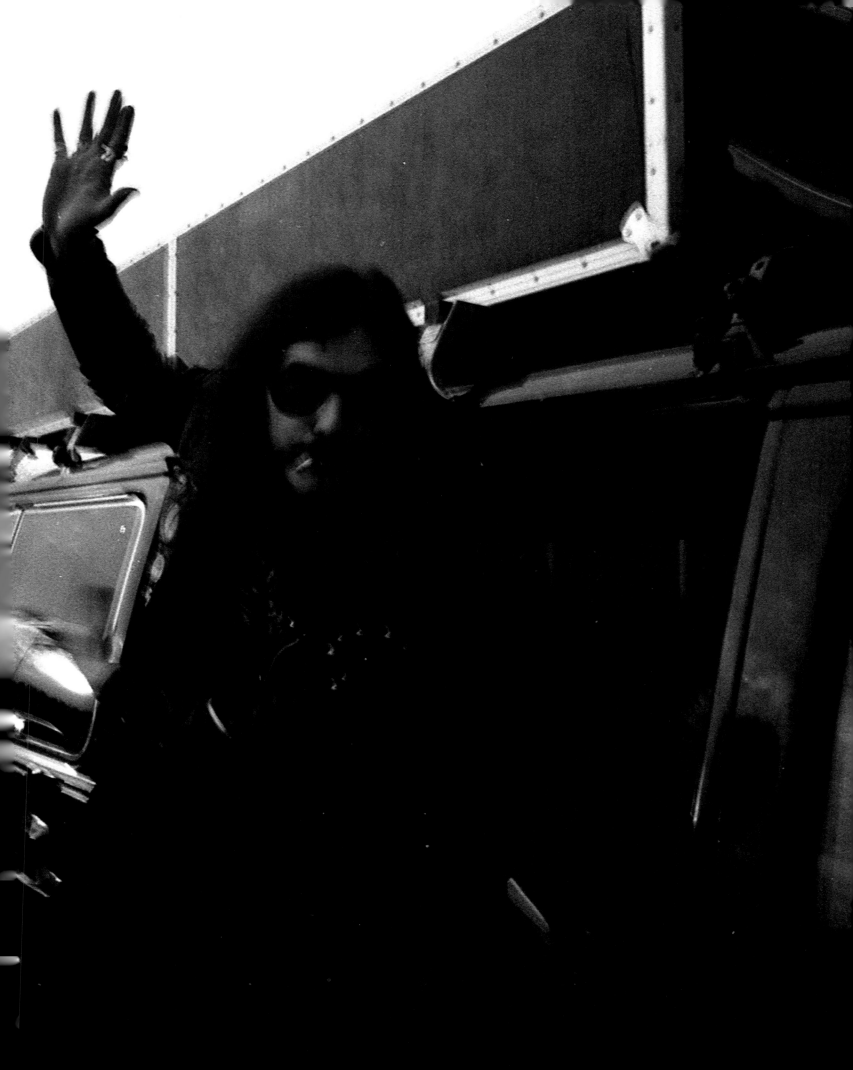

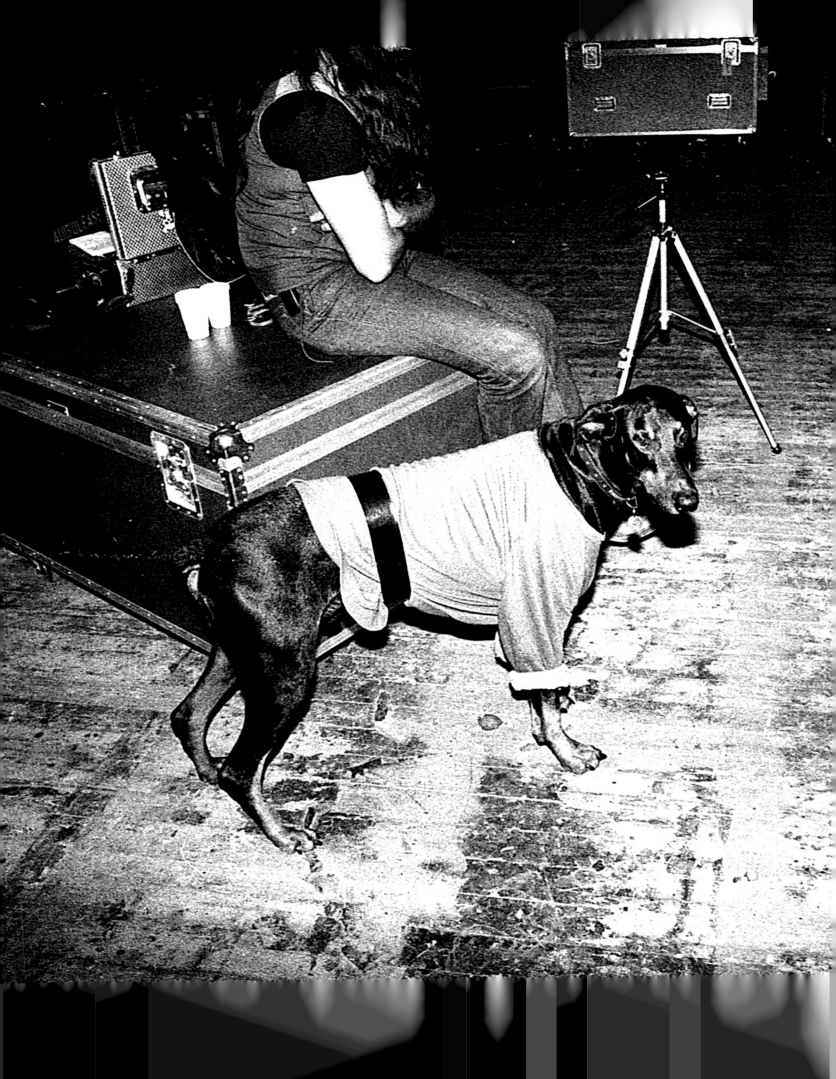

The dog in the t-shirt?
Buster. He was fellow
crew member Graham
Reynolds' dog, and was
often a tour companion.

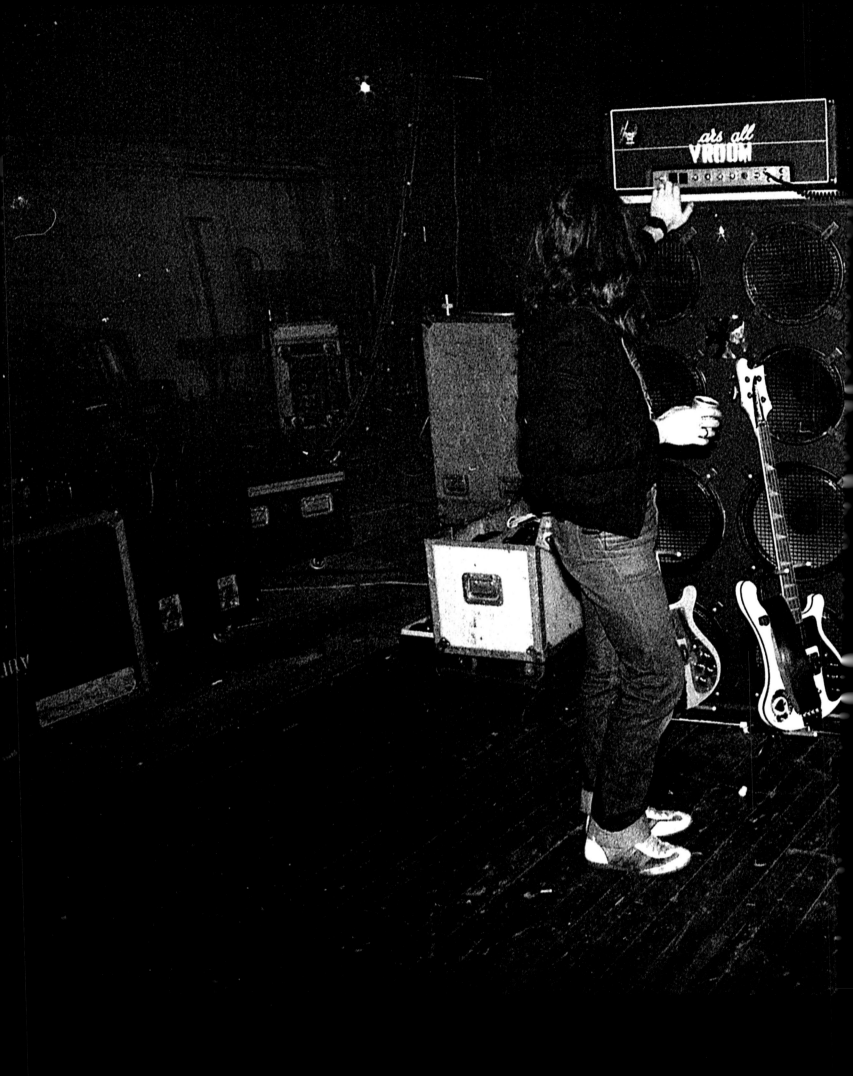

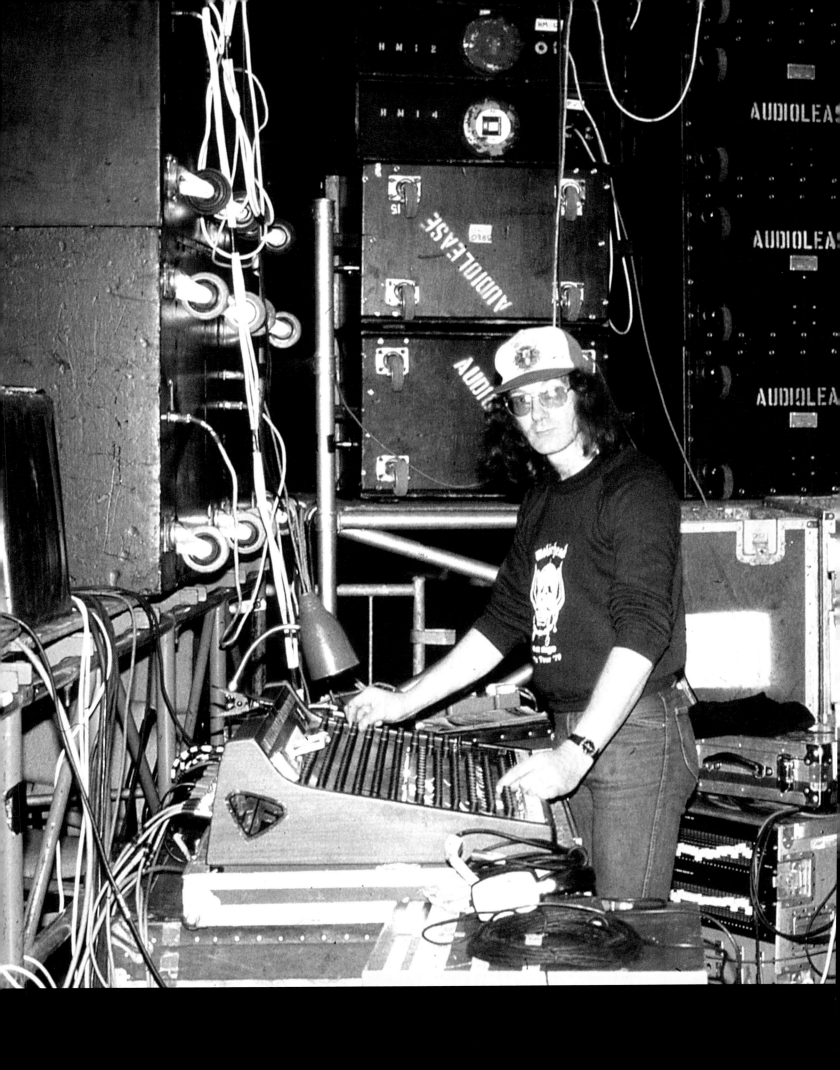

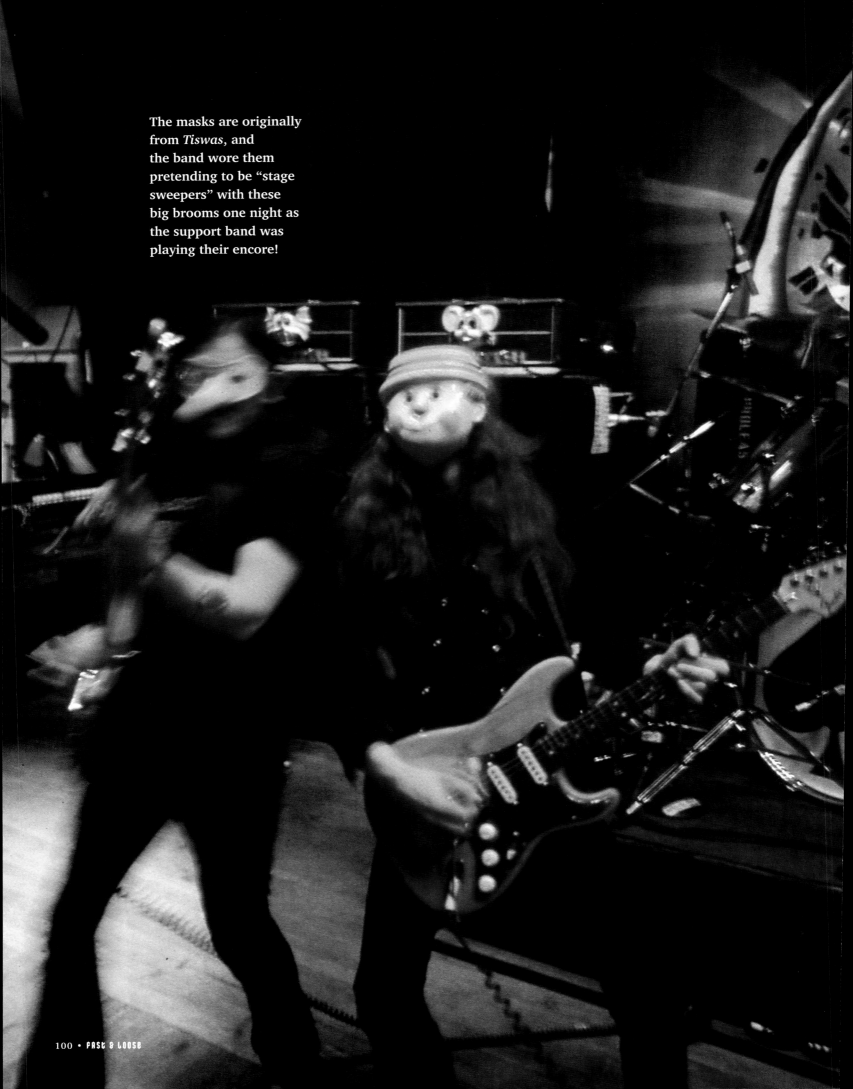

The masks are originally from *Tiswas*, and the band wore them pretending to be "stage sweepers" with these big brooms one night as the support band was playing their encore!

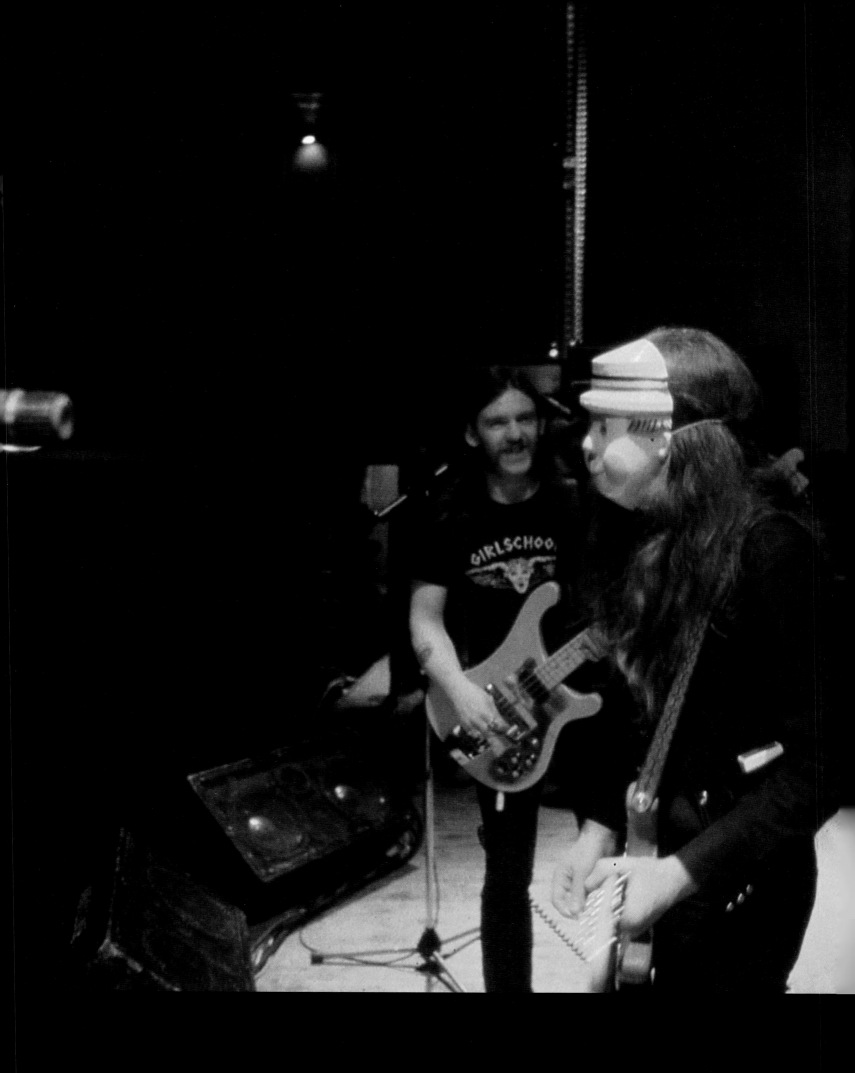

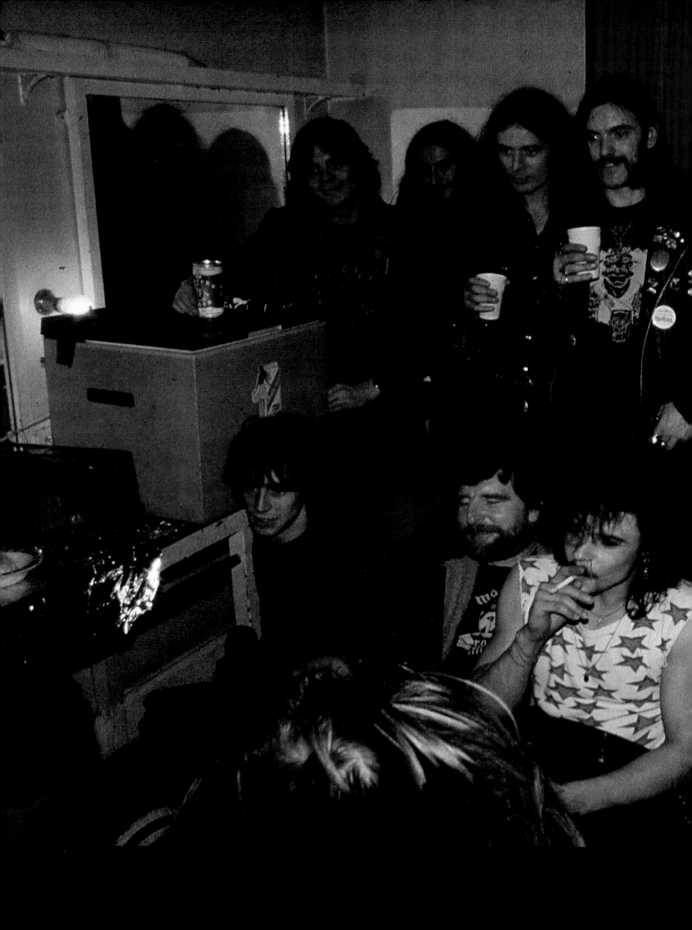

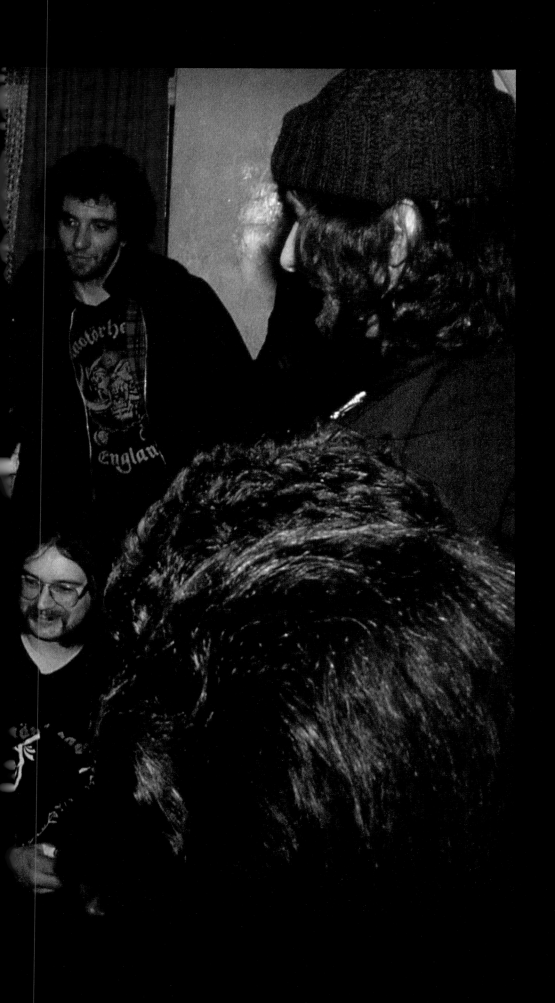

That's the road crew all gathered around watching the European Championships.

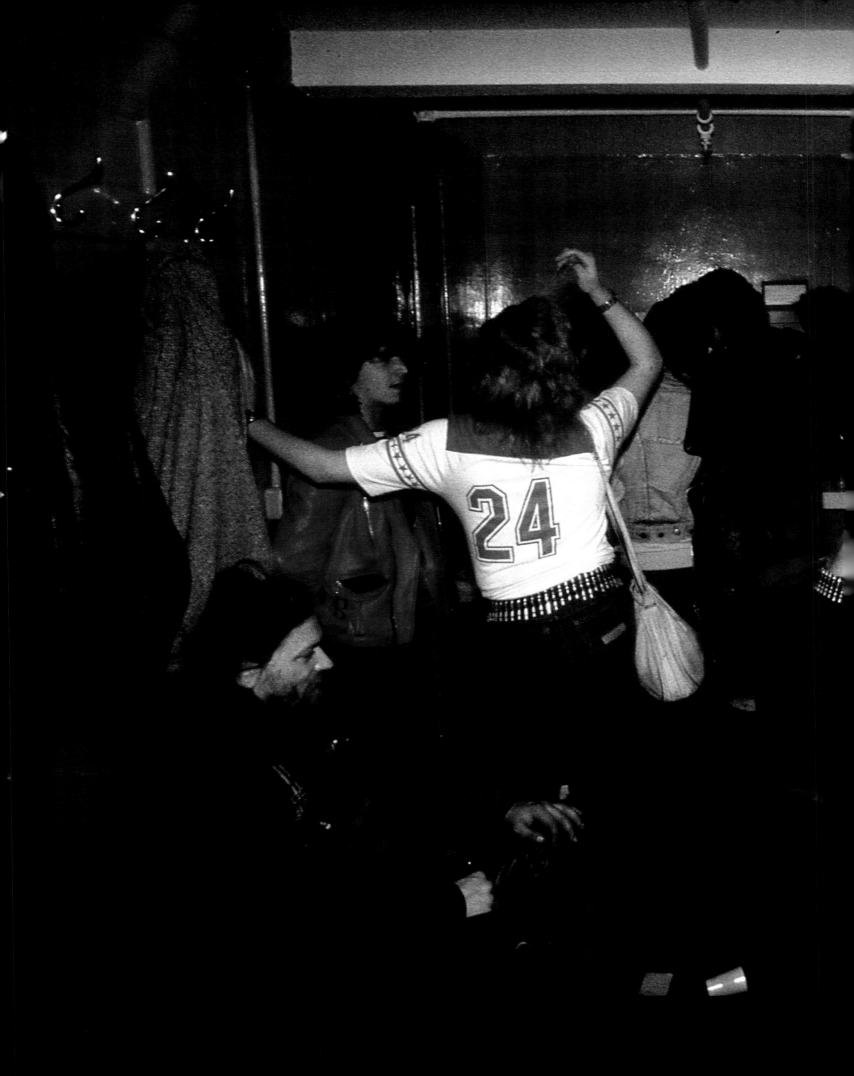

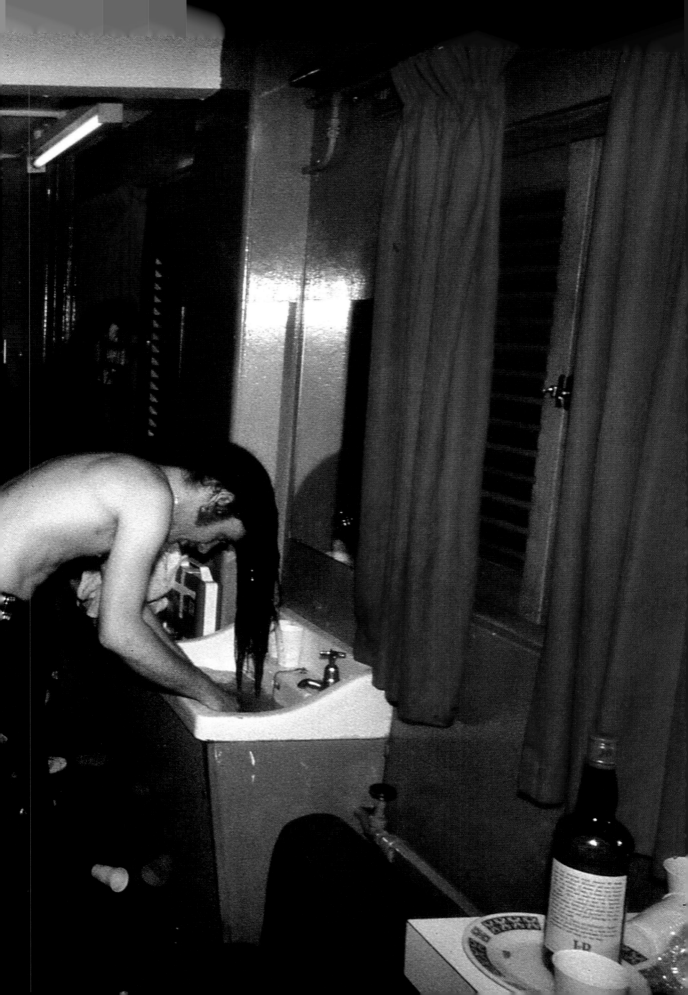

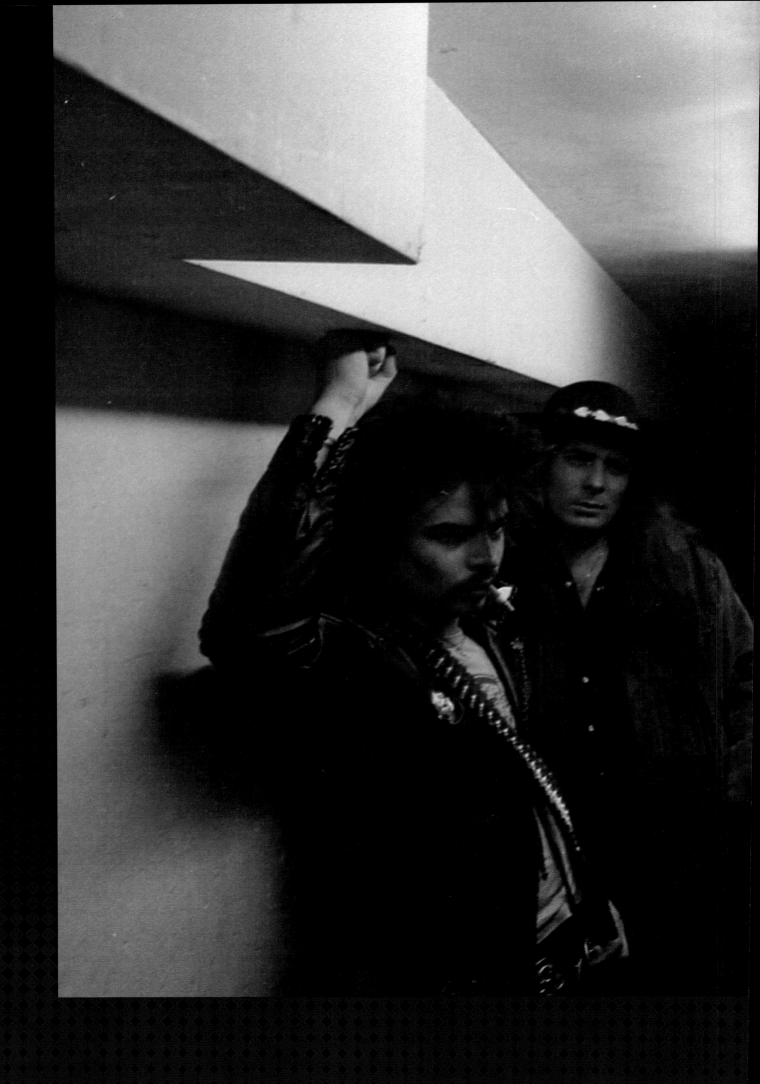

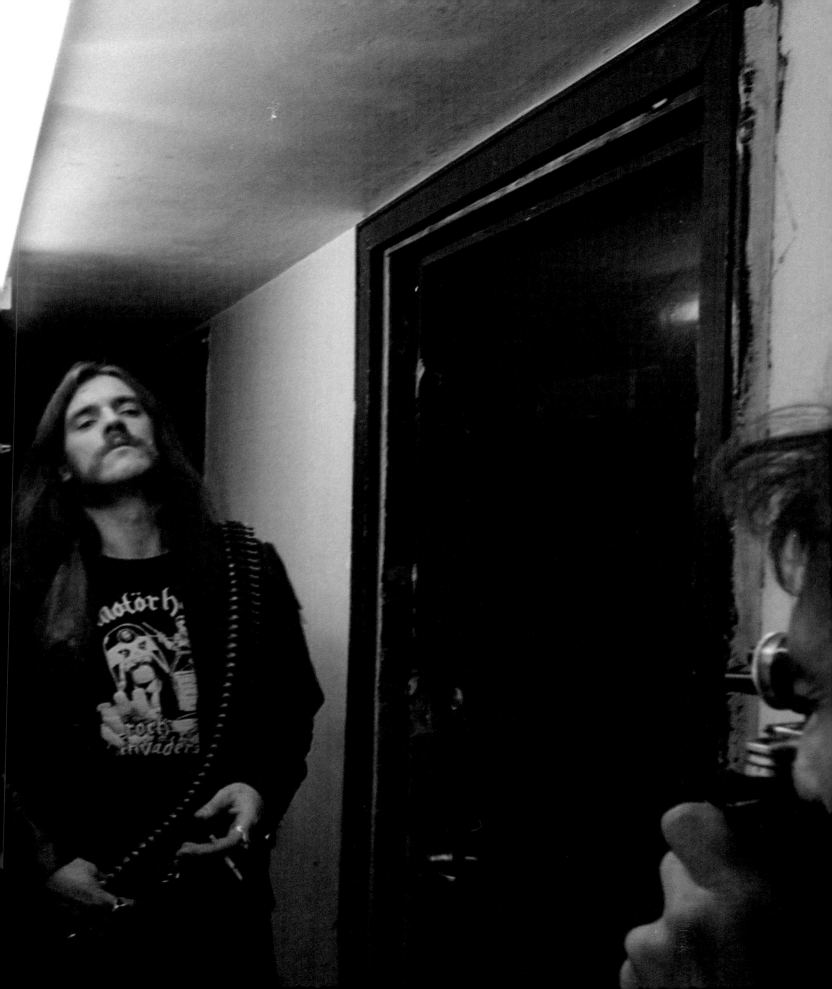

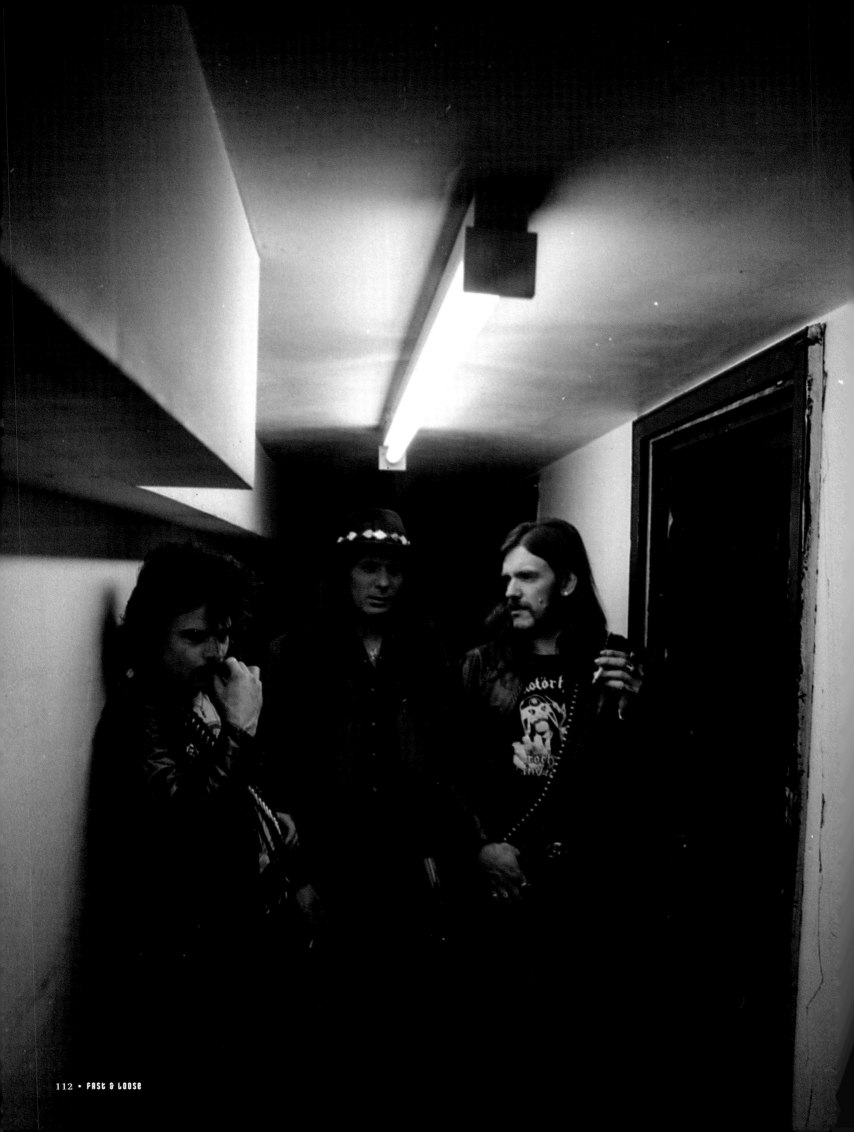

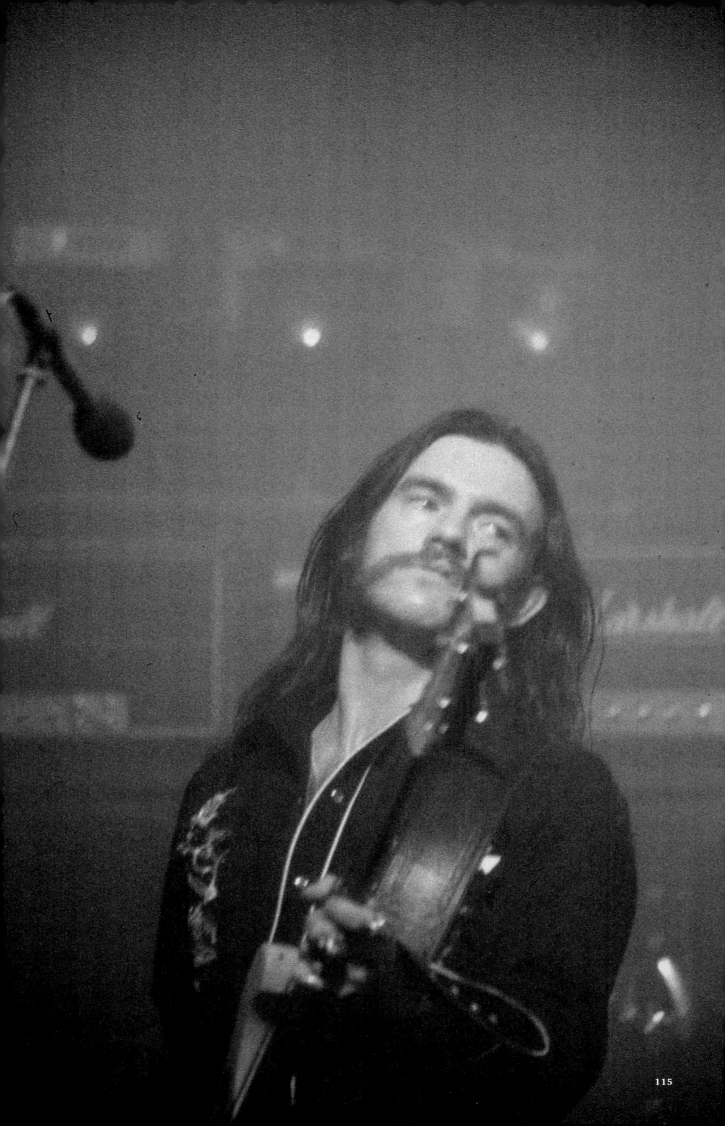

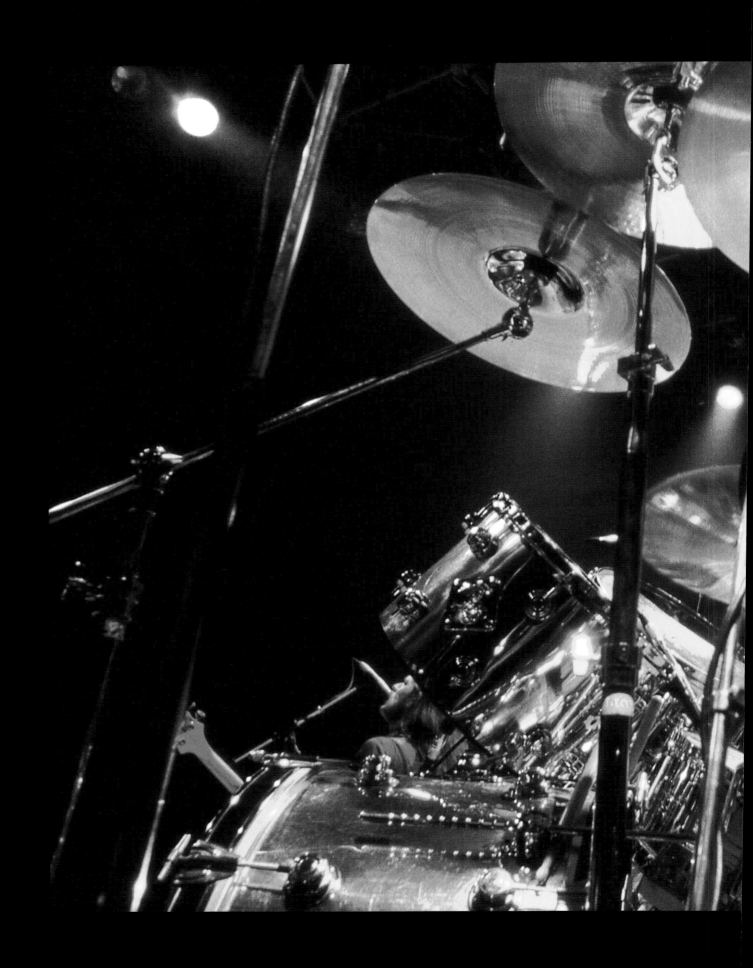

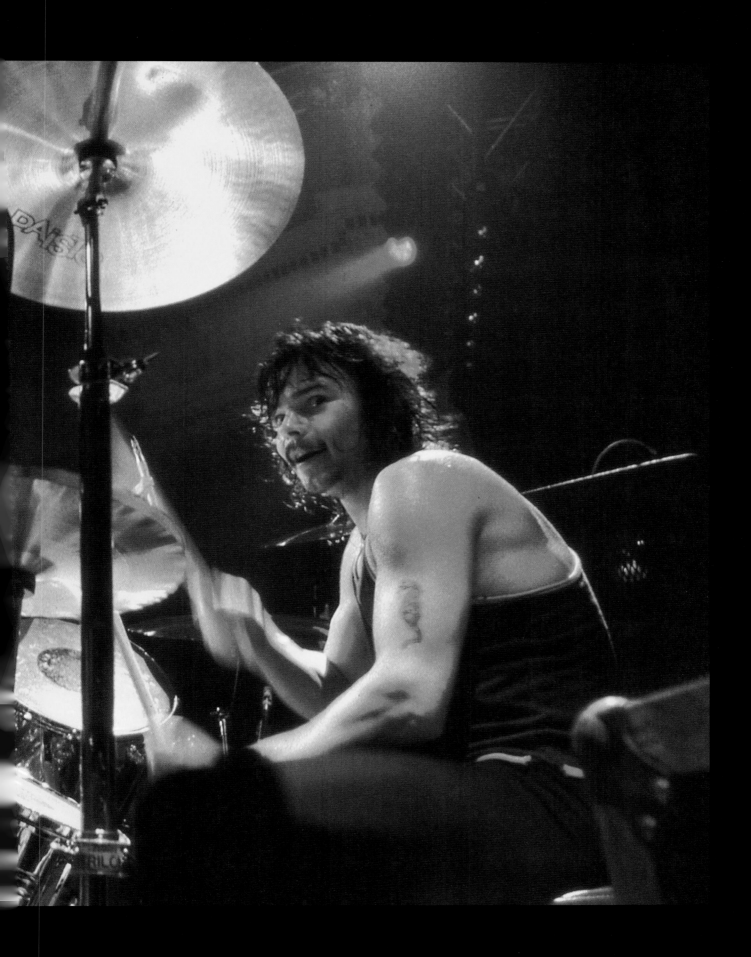

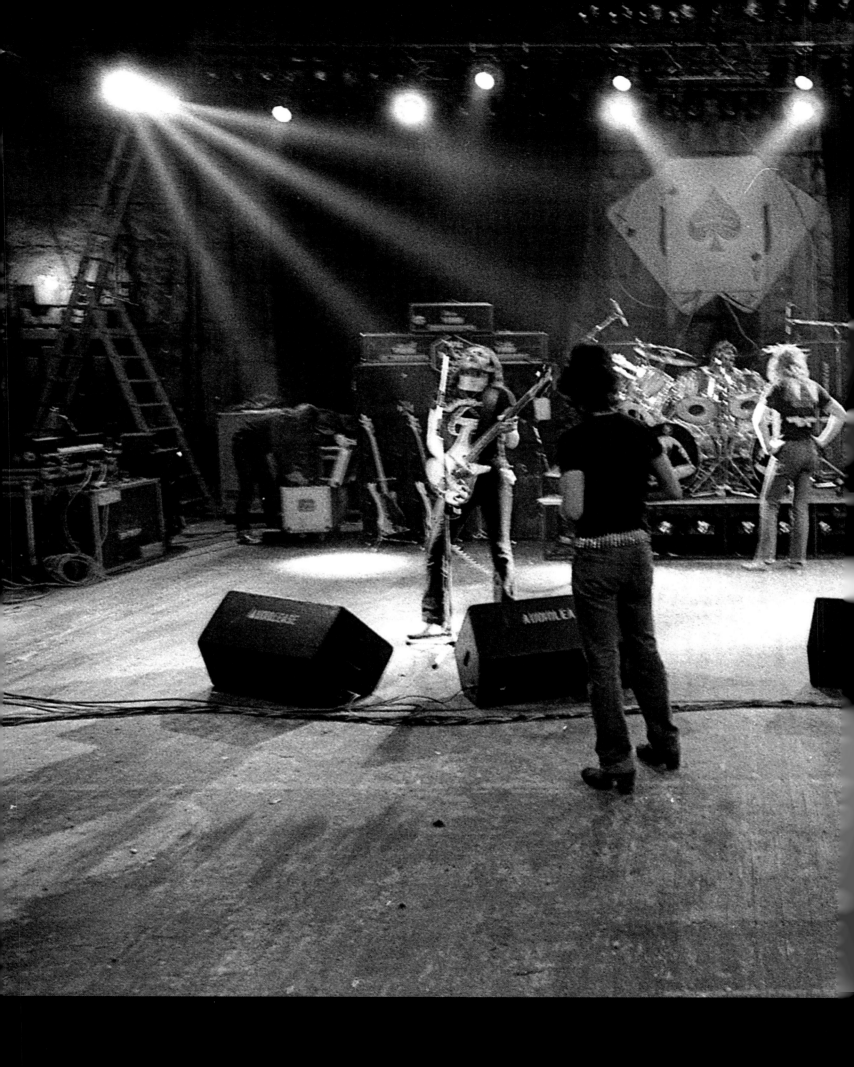

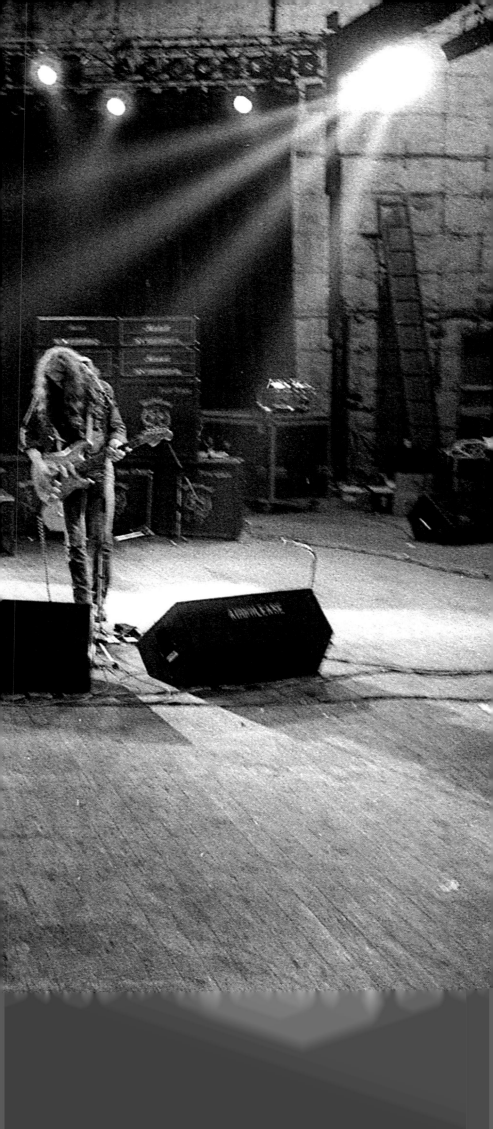

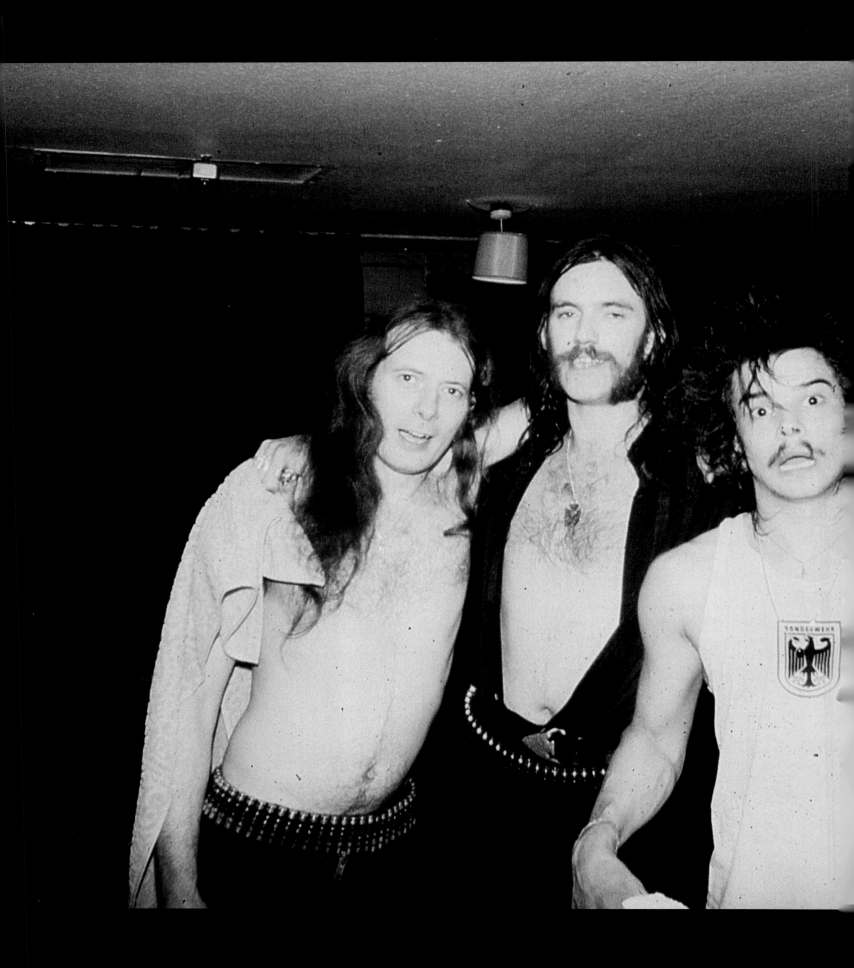

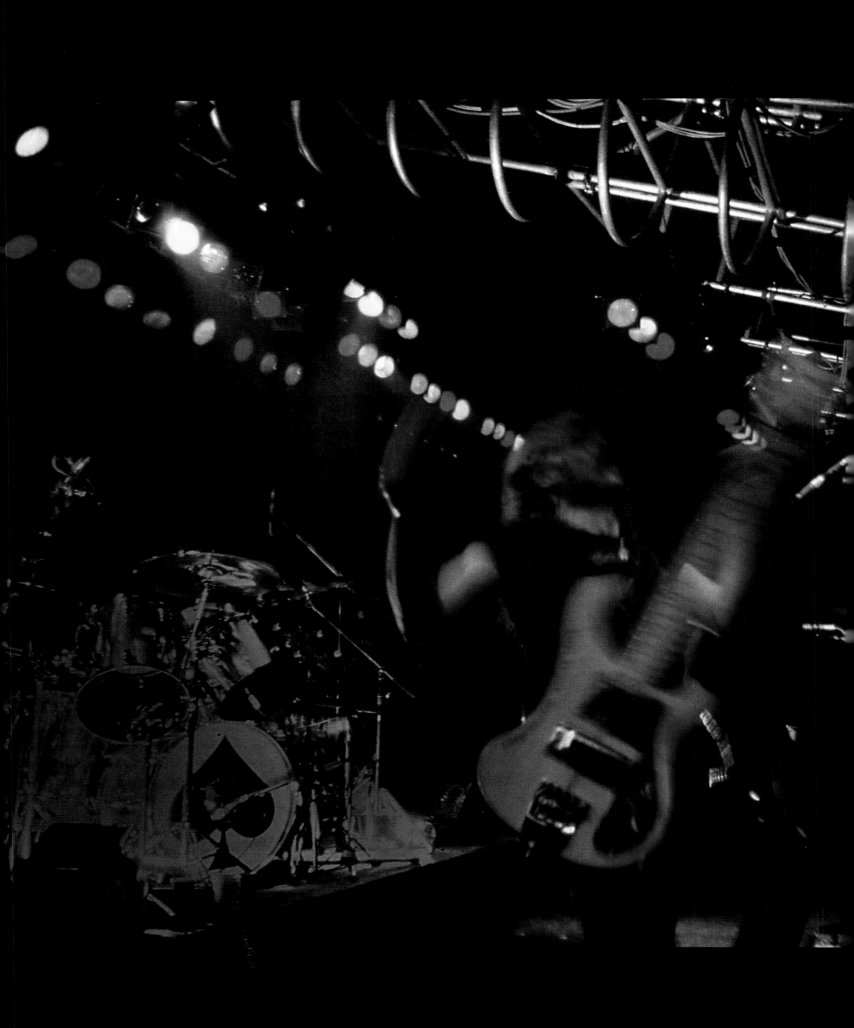

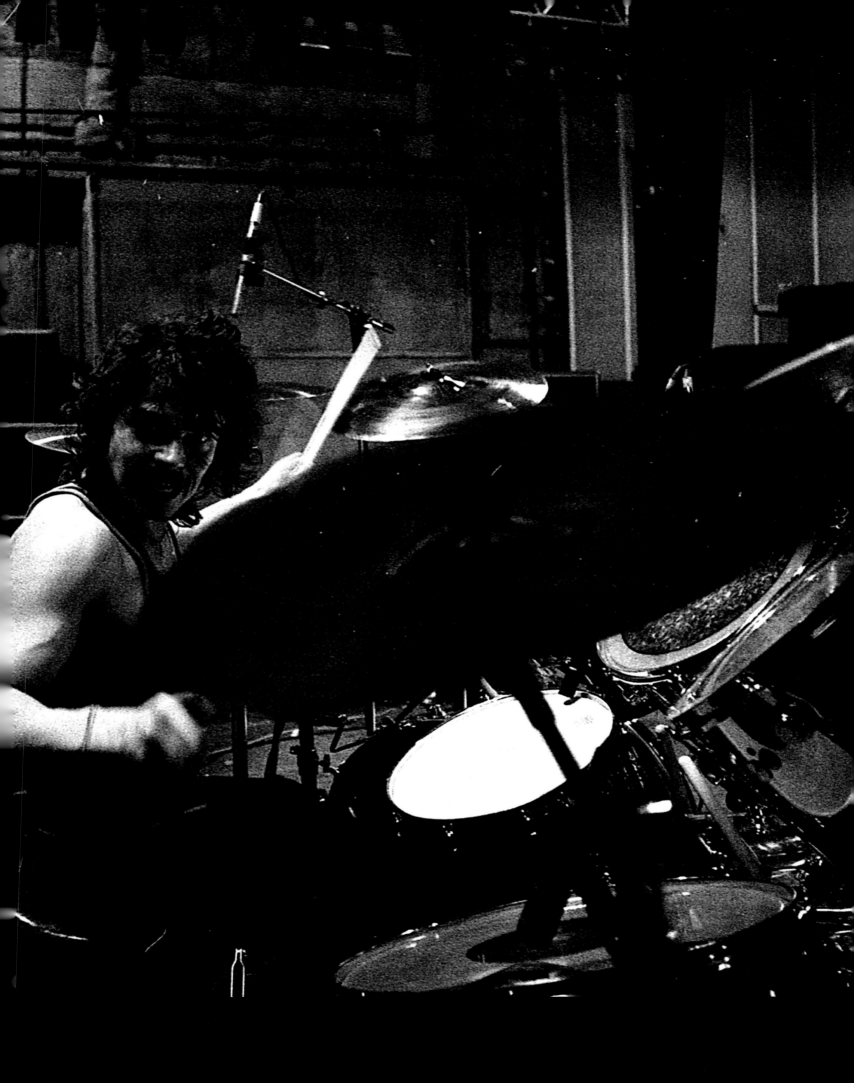

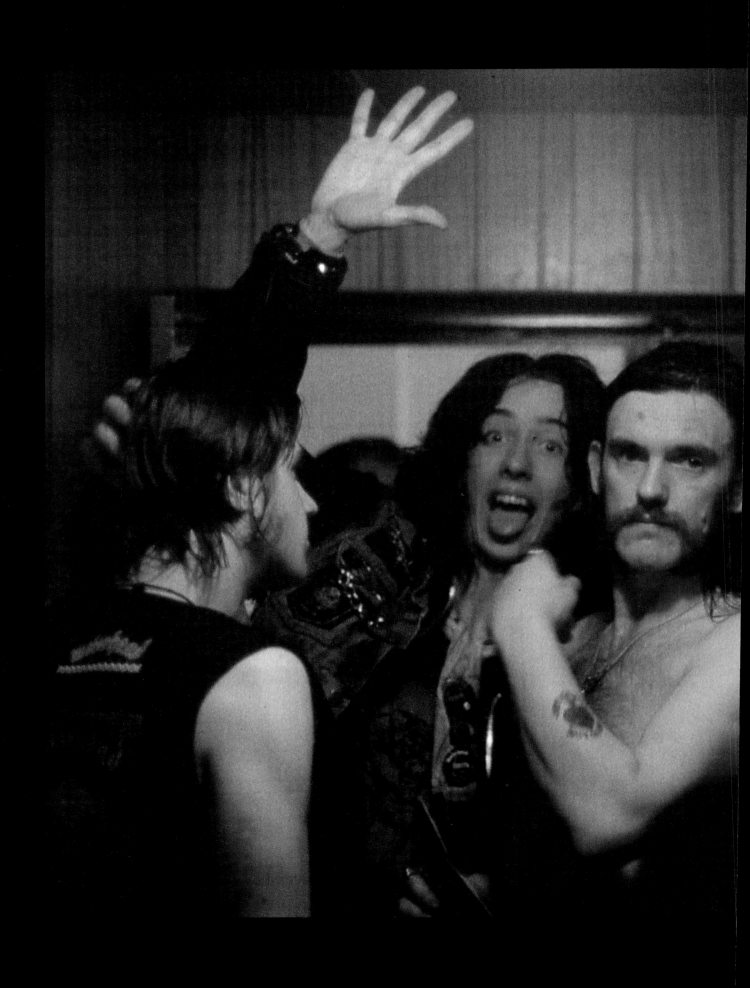

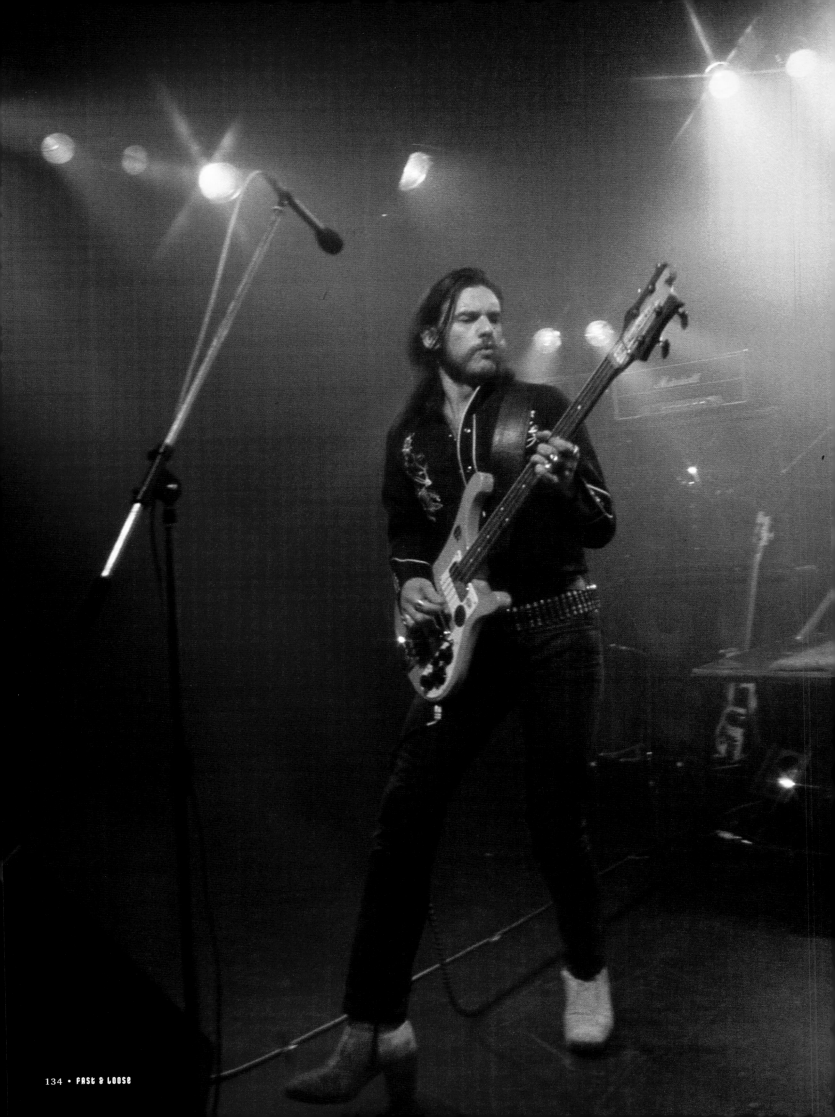

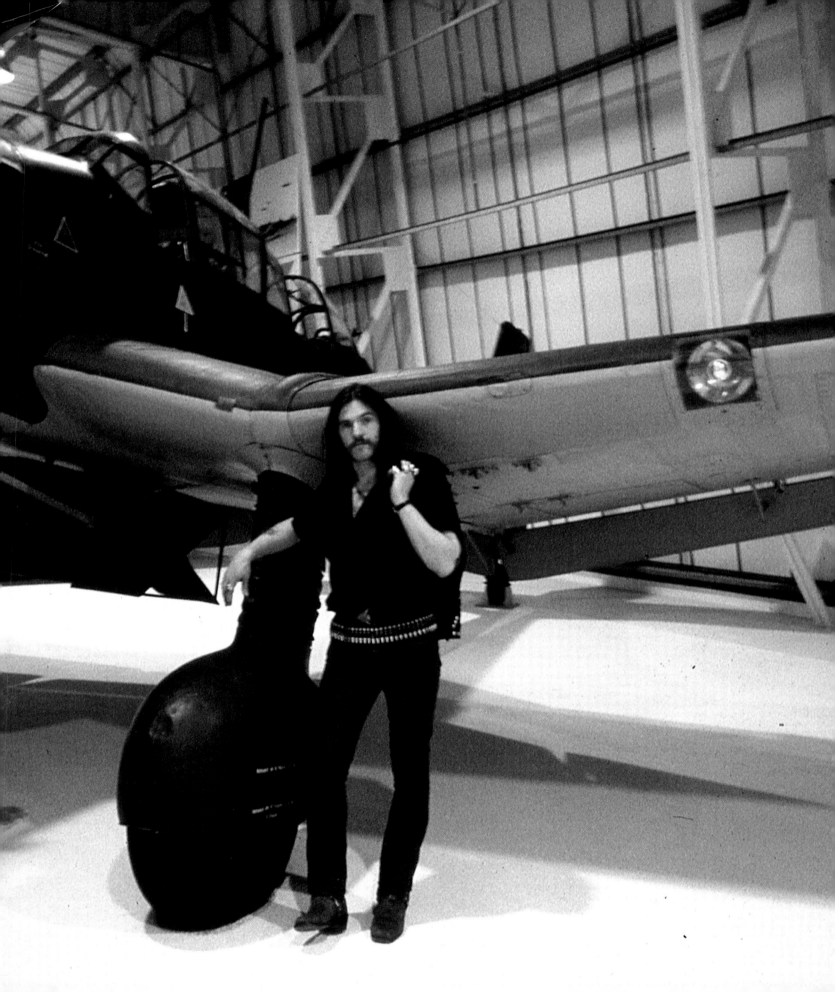

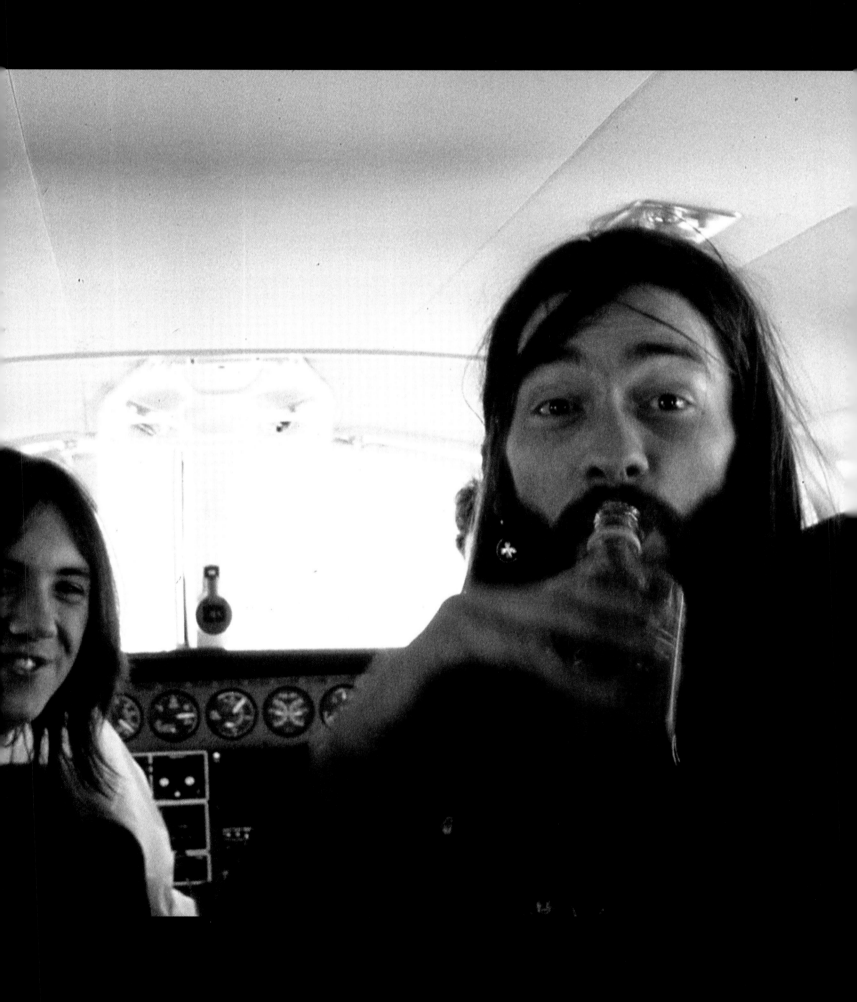

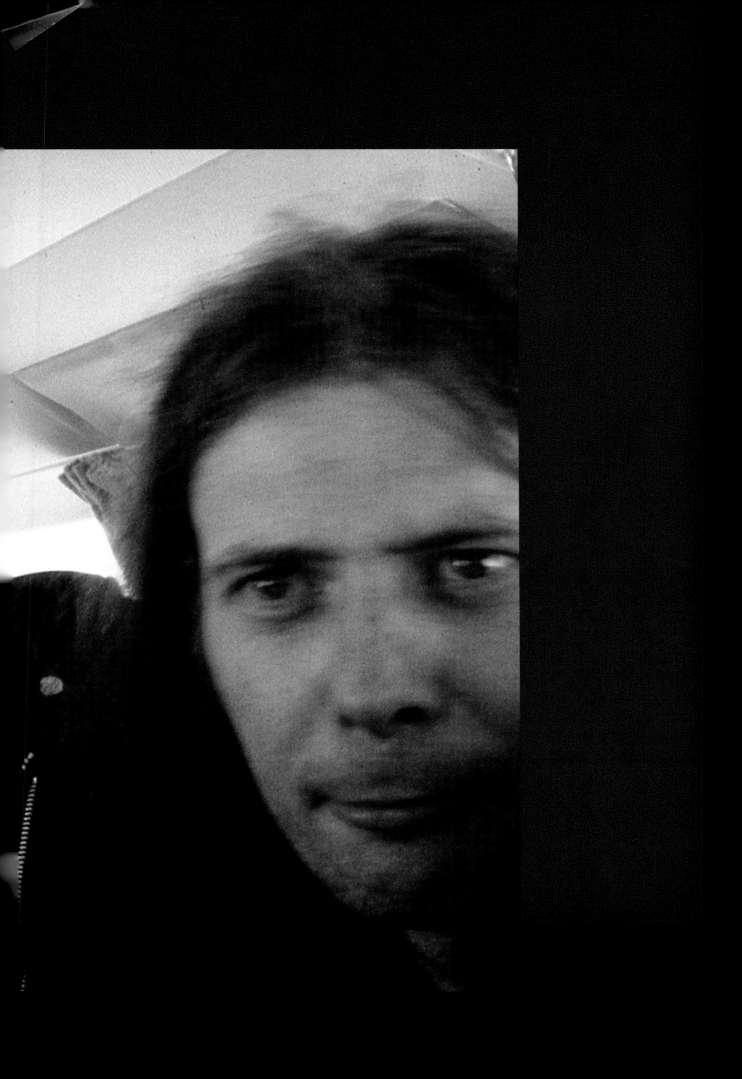

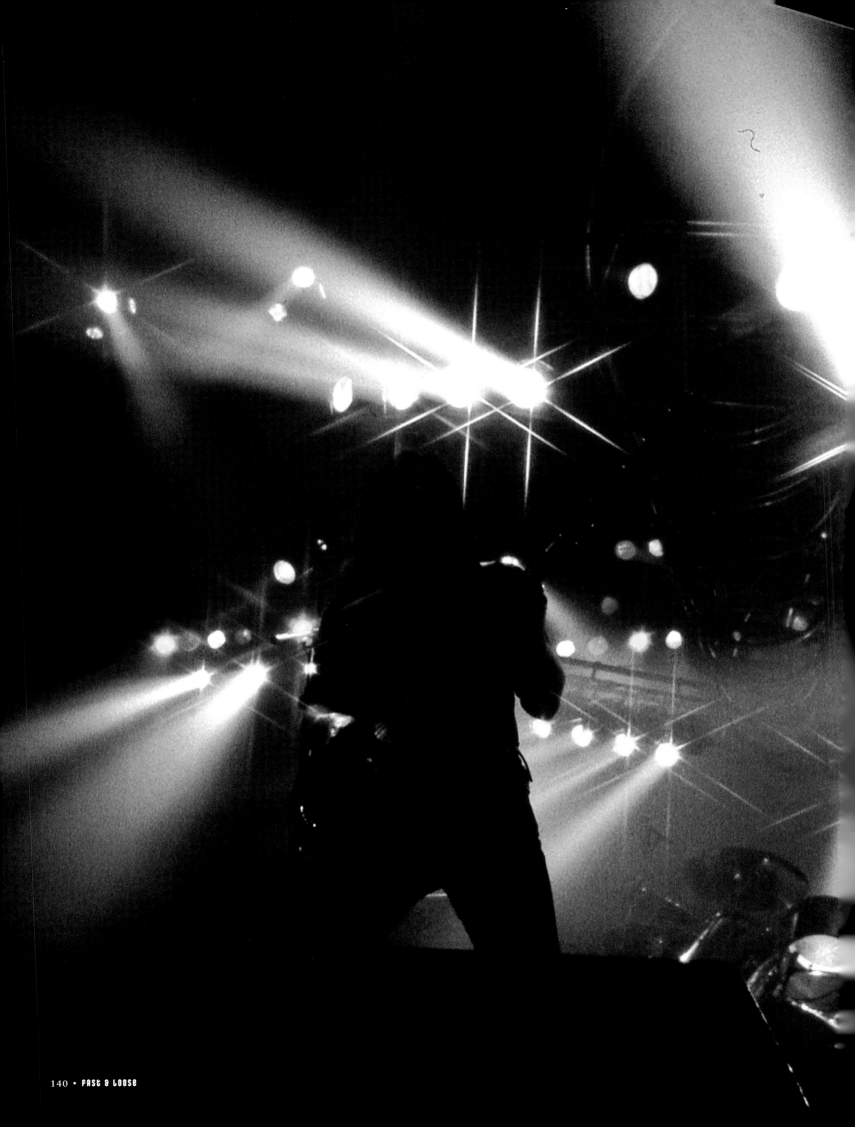

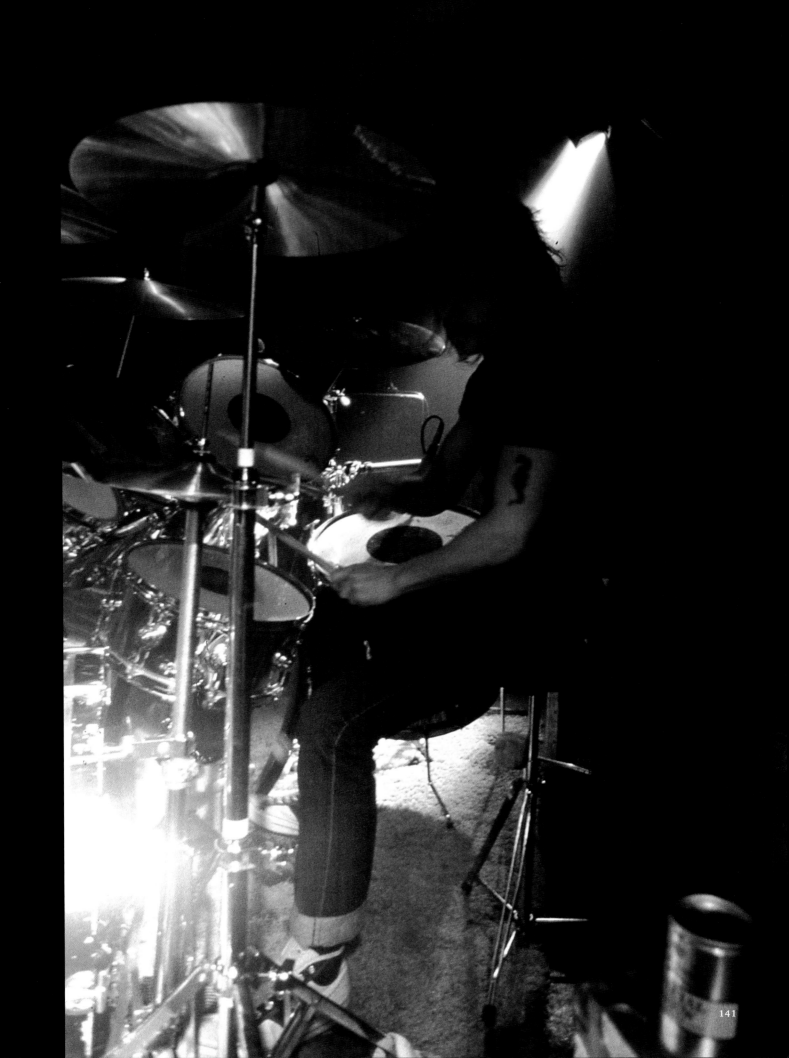

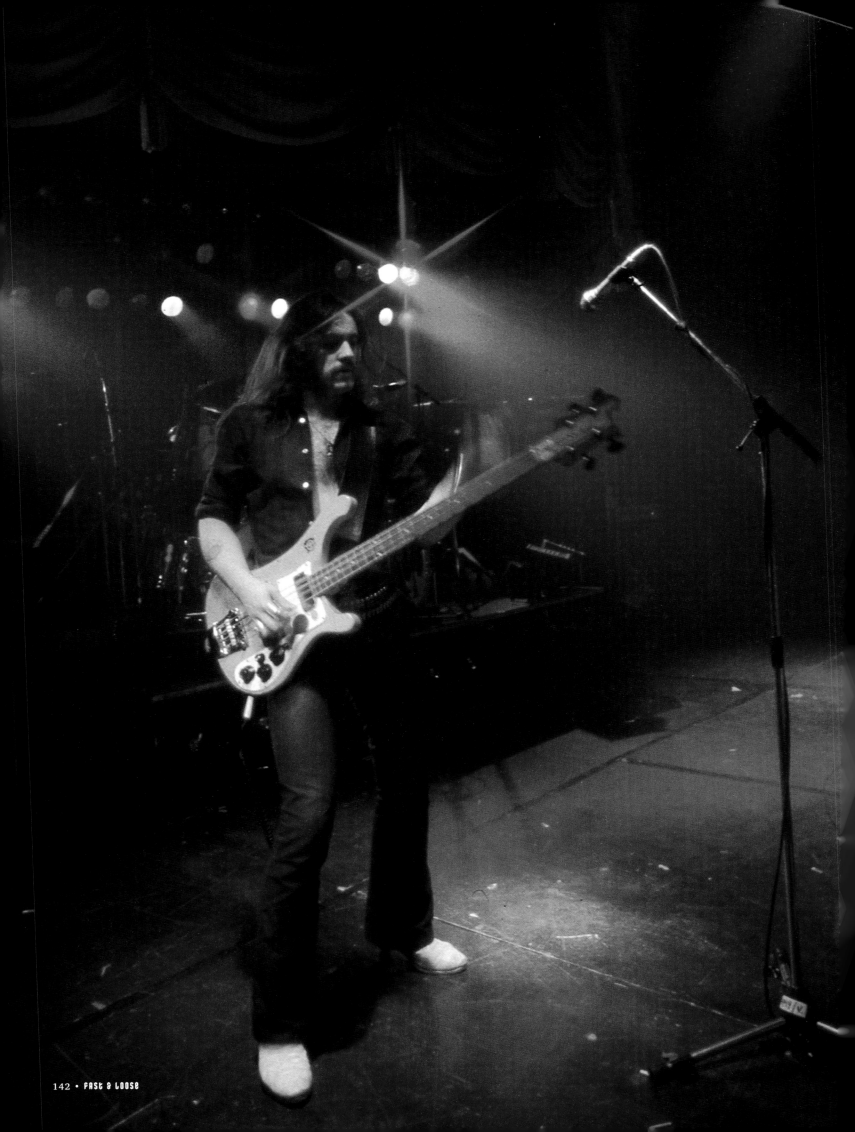

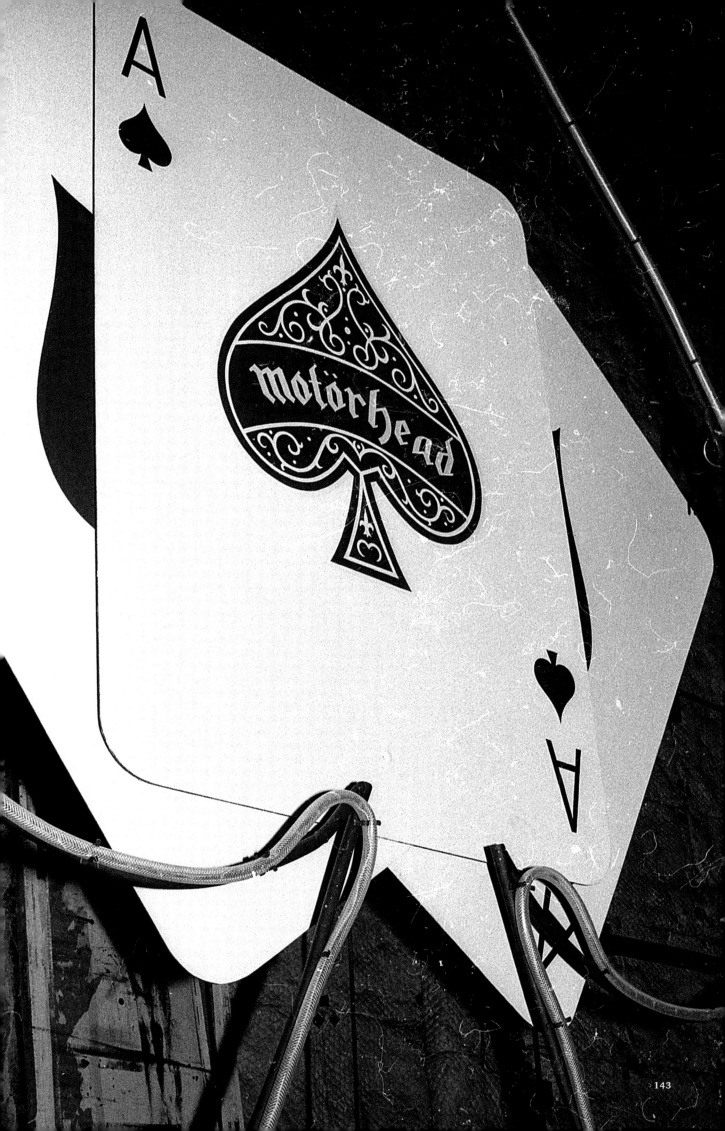

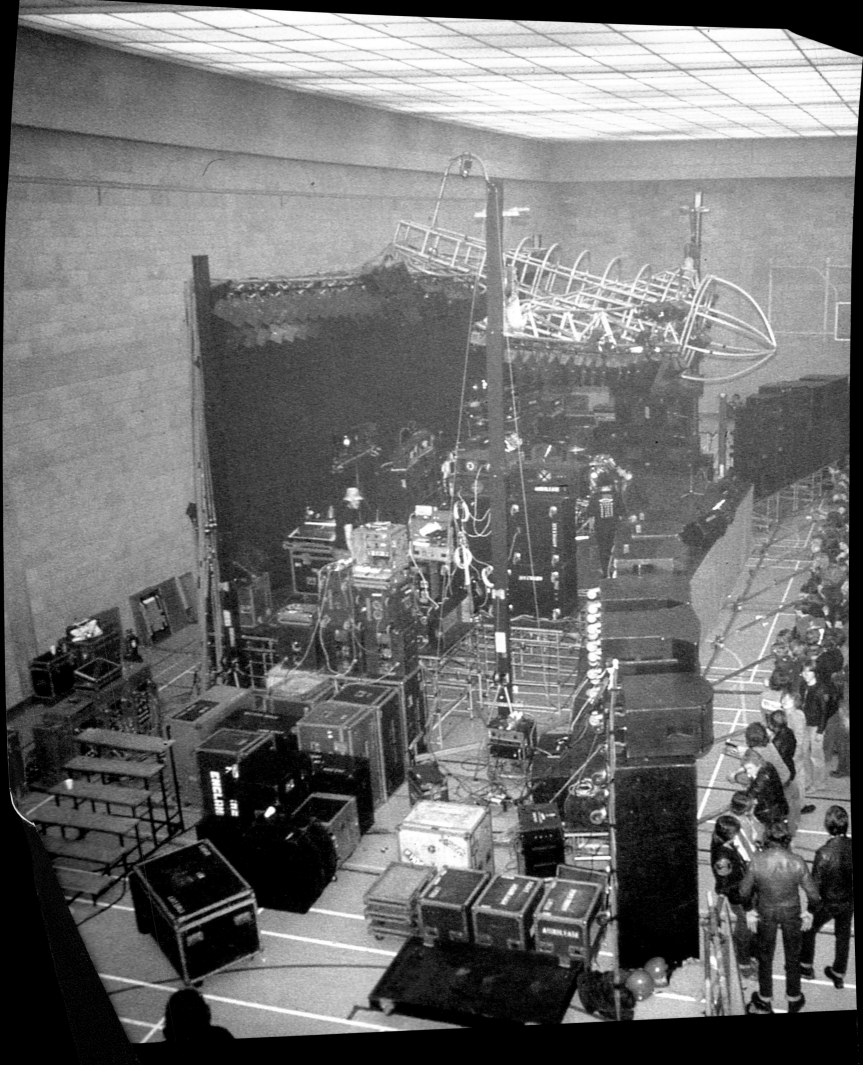

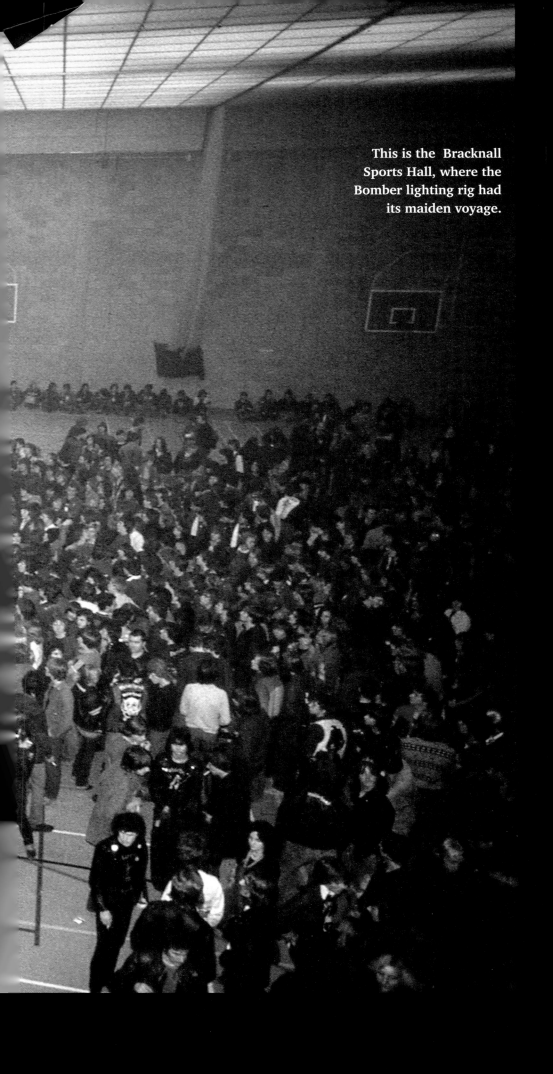

This is the Bracknall
Sports Hall, where the
Bomber lighting rig had
its maiden voyage.

Every night the
crowd would go
fucking ape. They
were total fucking
fanatics, and
Motörhead was
like a V8 fucking
American motor,
just roaring and
slamming it through.

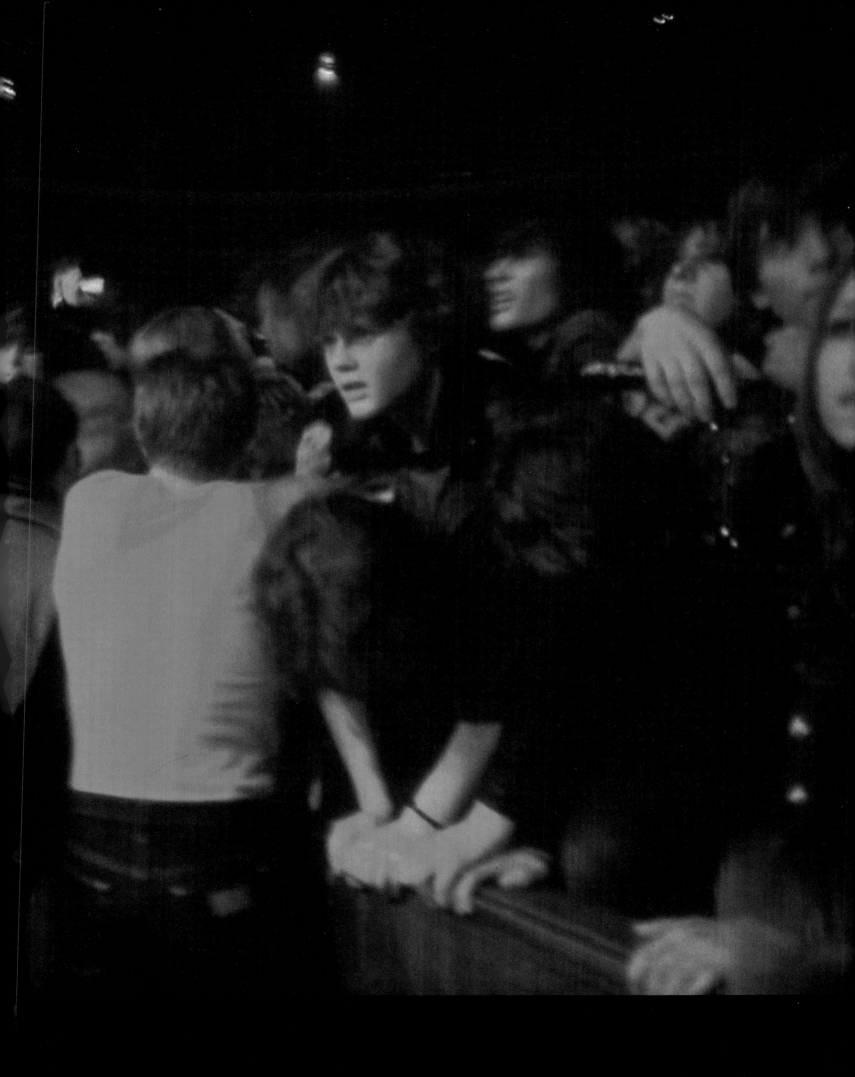

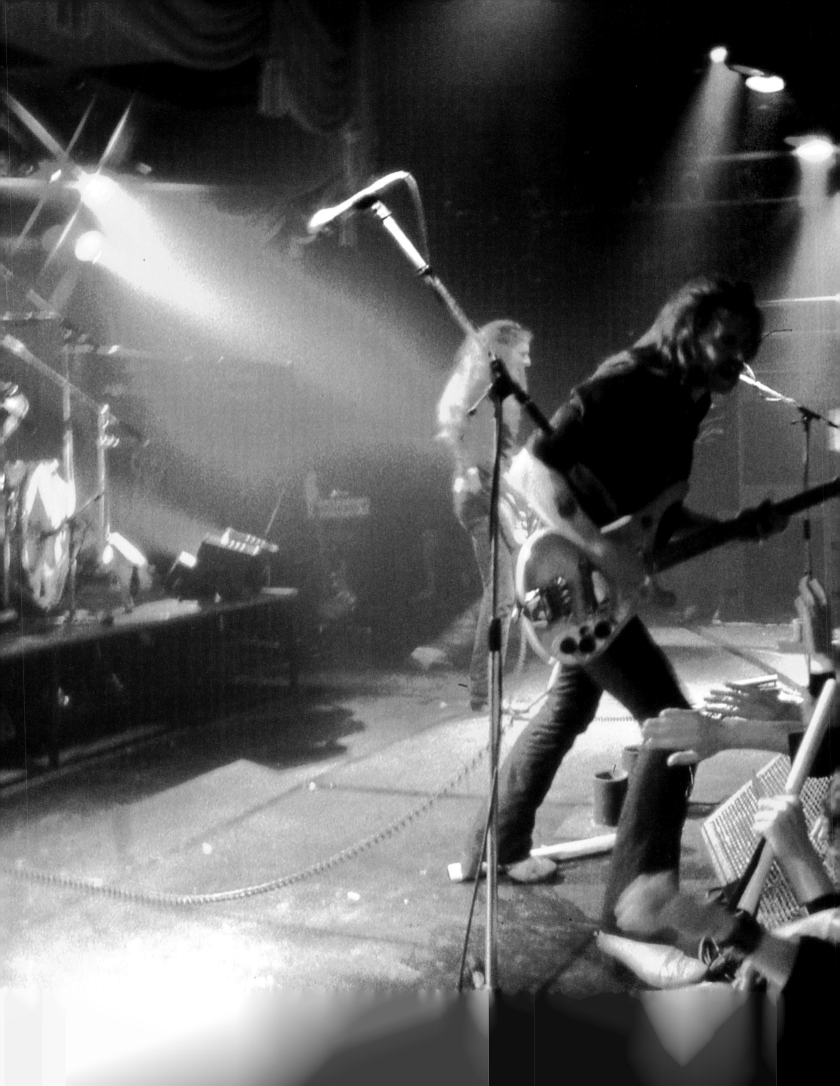

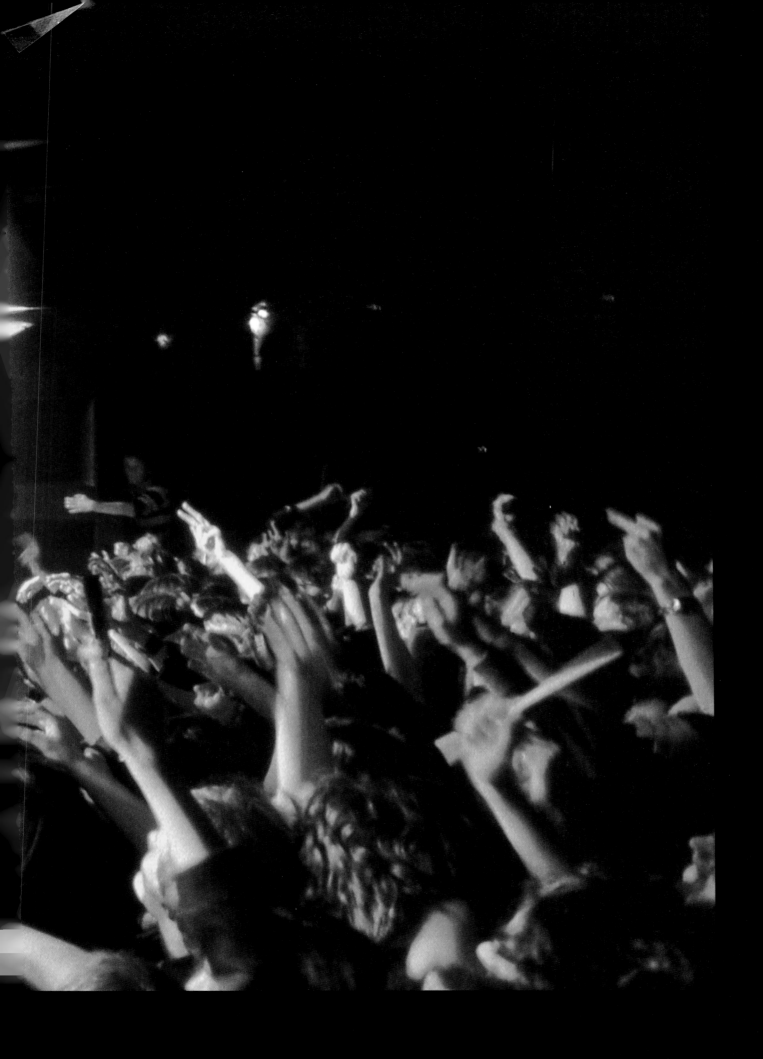

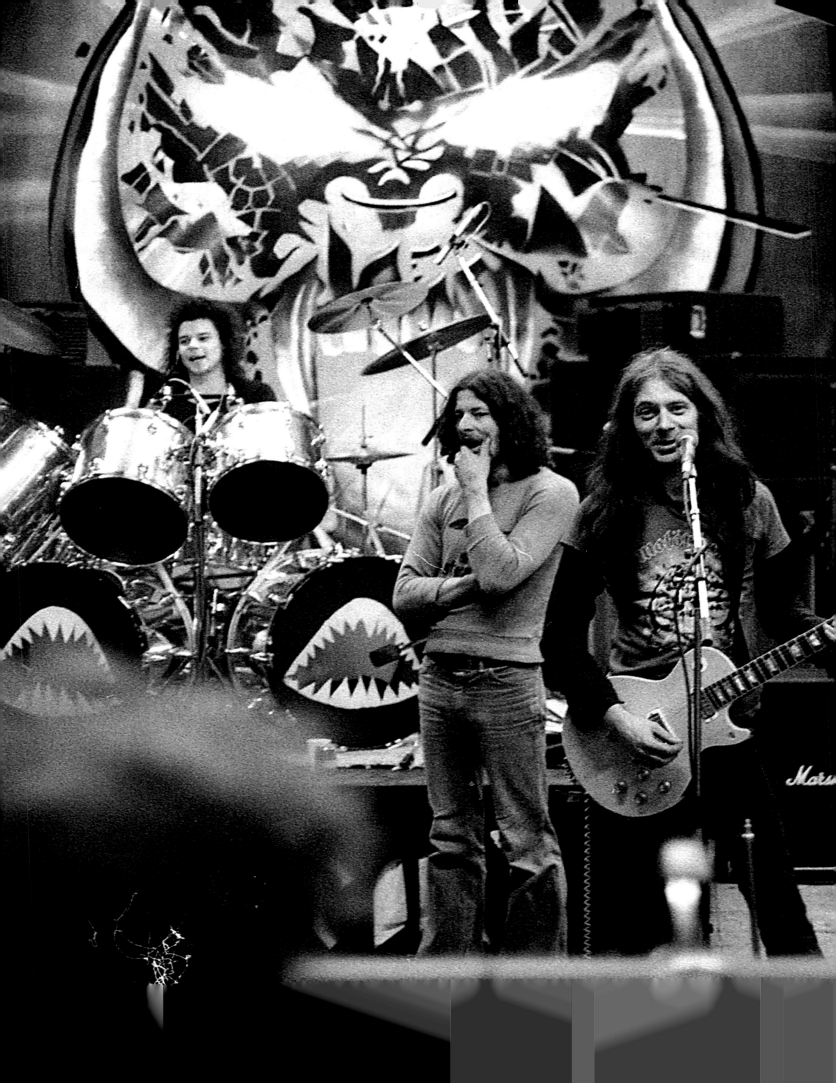

Overkill era rehearsal, with some serious giggling and pondering going on.

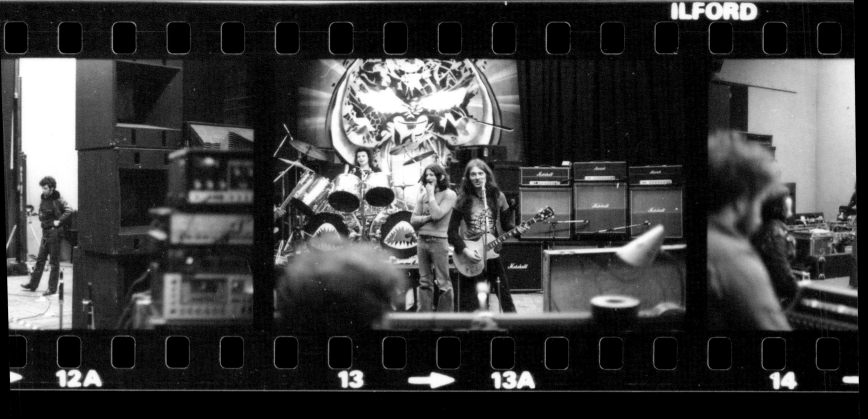

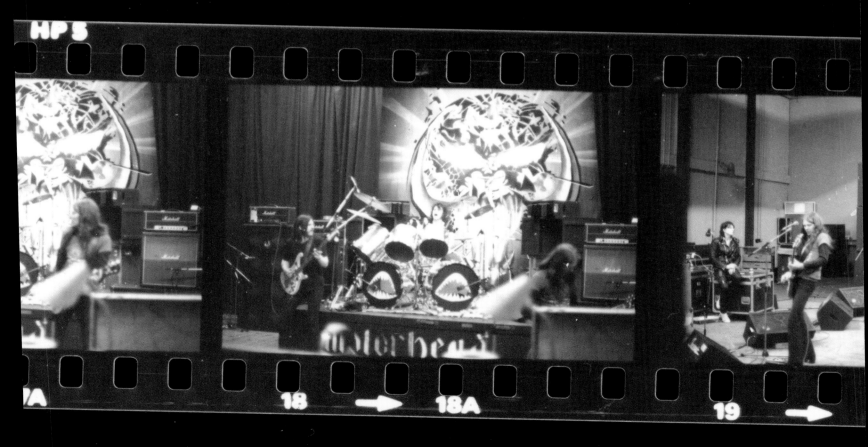

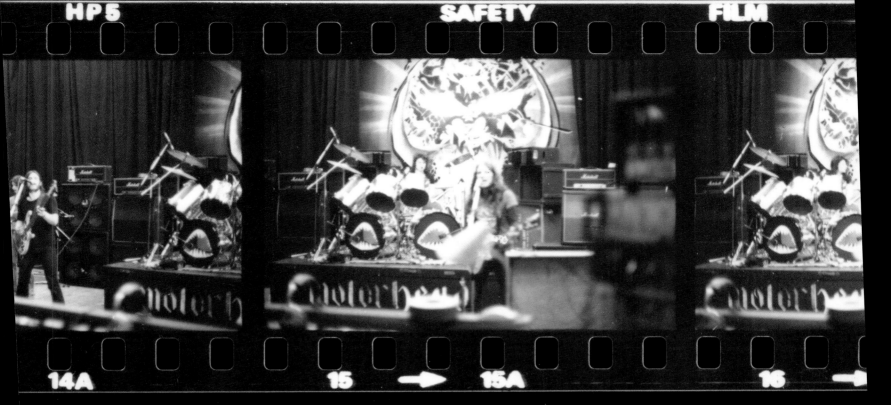

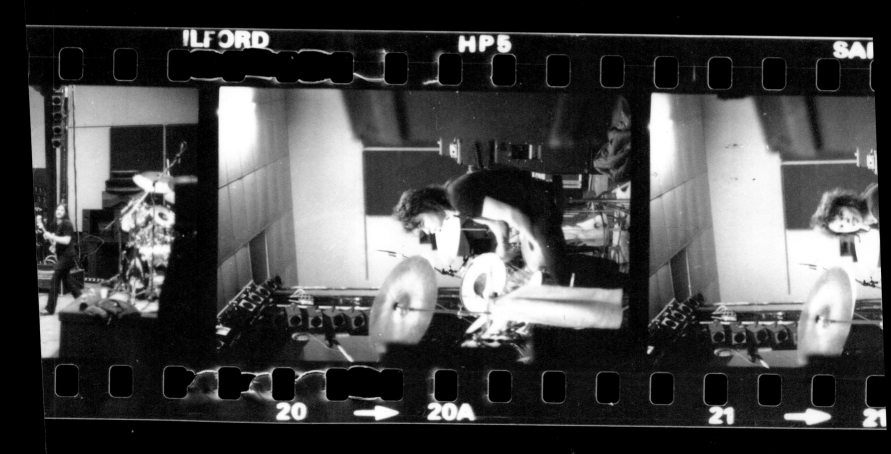

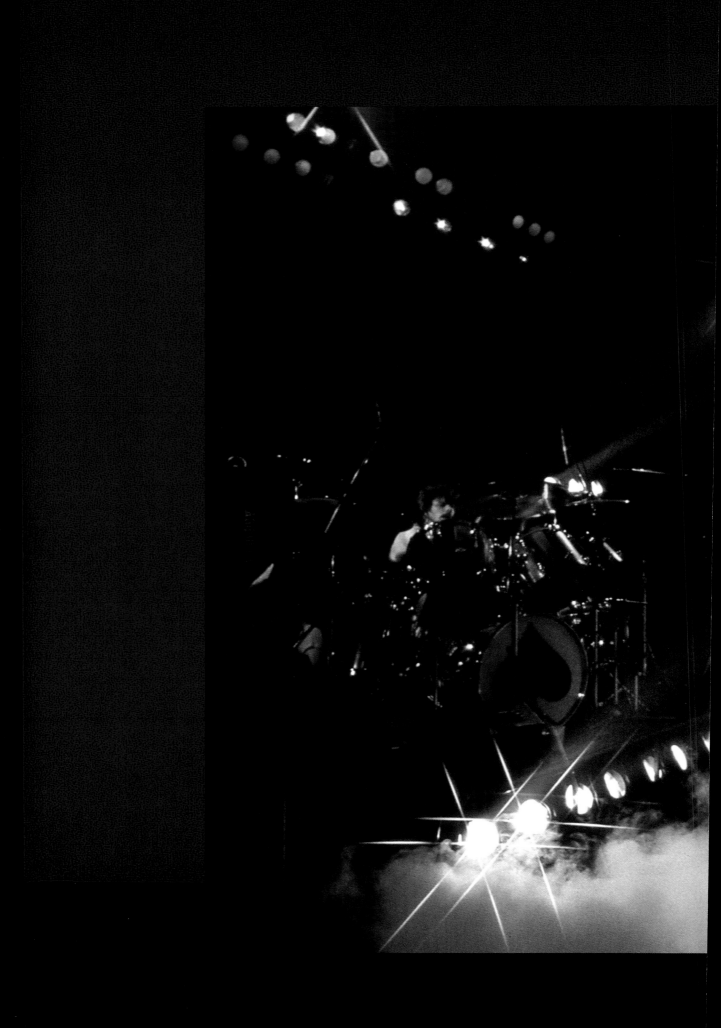

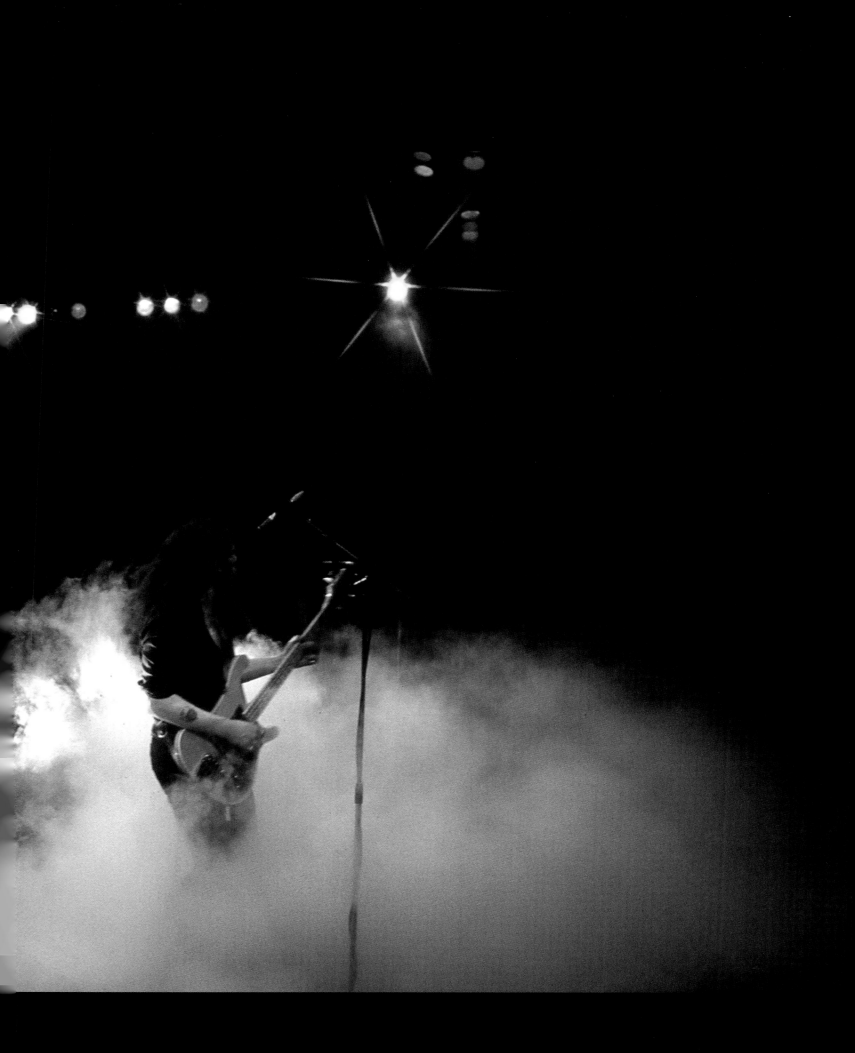

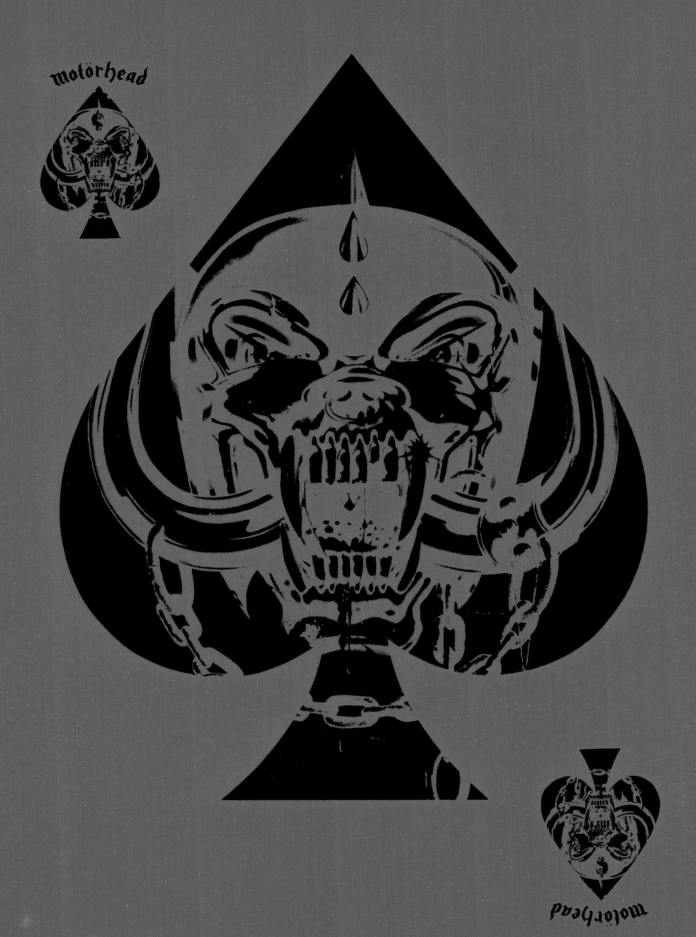

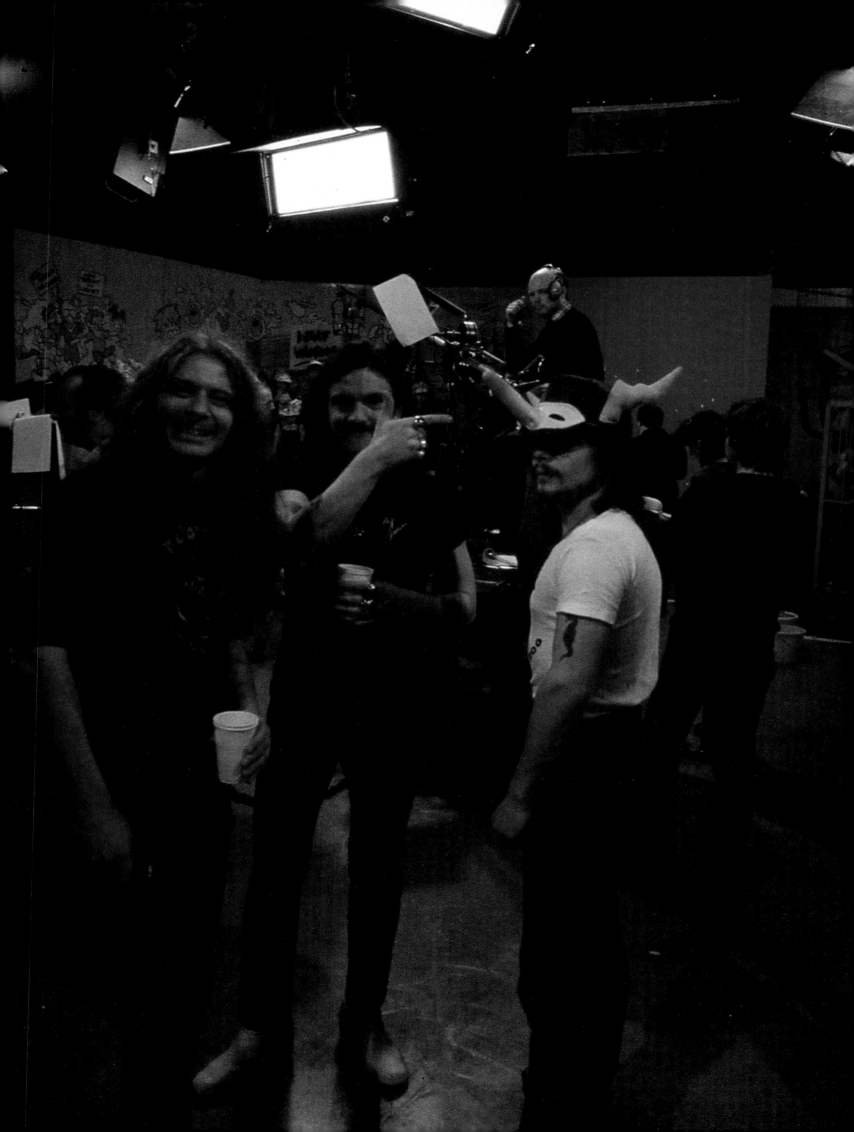

Motörhead: Fast & Loose
Snapshots from the Graham Mitchell Archive, 1977-1982

Design by Patrick Crowley

All photographs from the collection of Graham Mitchell, Copyright © Murder One, Inc.

Library of Congress Cataloging-in-Publication Data available upon request.

ISBN: 9781947026988

Published by BMG
bmg.com

imotorhead.com